IMAGES
of Rail

LAKE TAHOE'S
RAILROADS

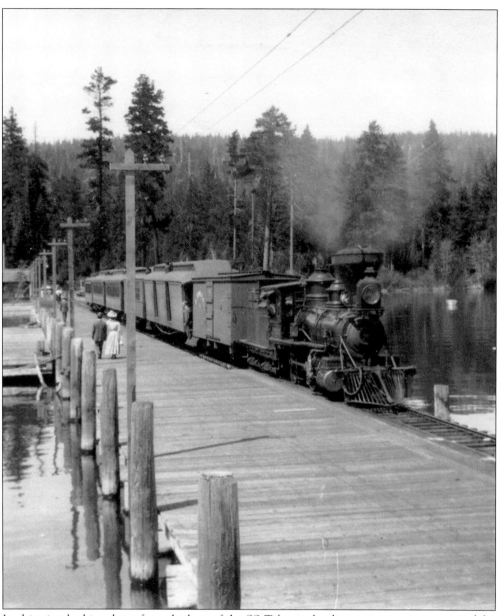

In this view looking down from the bow of the SS *Tahoe* is the diminutive morning train of the Lake Tahoe Railway & Transportation Company, fresh in from Truckee with its load of passengers for the day trip around the lake. The daily summer arrival of the narrow-gauge freight and passenger train on the Tahoe Tavern Wharf was an essential component of Lake Tahoe tourism during the first quarter of the 19th century. (Roy D. Graves collection.)

ON THE COVER: The Carson & Tahoe Lumber & Fluming Company train crew volunteered for Sunday picnic duty. Photographer R.B. Middlemiss had the locomotive pause at Devil's Gate at Lower Pray Meadows, just up from Glenbrook on the Nevada side of Lake Tahoe. Locals and visitors pose for the July 1896 photograph, but it is Ralph Barrett (left), Zelma Griffin (center), and Milton Keyser, the three youngsters in the foreground, who steal the show. (California State Railroad Museum.)

IMAGES
of Rail

LAKE TAHOE'S
RAILROADS

Stephen E. Drew

ARCADIA
PUBLISHING

Published by Arcadia Publishing
Charleston, South Carolina

Printed in the United States of America

Library of Congress Control Number: 2016935825

For all general information, please contact Arcadia Publishing:
Telephone 843-853-2070
Fax 843-853-0044
E-mail sales@arcadiapublishing.com
For customer service and orders:
Toll-Free 1-888-313-2665

Visit us on the Internet at www.arcadiapublishing.com

To Naomi and Eleanor, so you will know
what grandpa has been working on.

CONTENTS

ACKNOWLEDGMENTS

A loosely knit group of Virginia & Truckee Railroad enthusiasts—Jon O. Nagel, the late James C. Dunn, and Fred Barber—convinced me early on about the value of letting the artifacts "talk" while walking the remains of the Carson & Tahoe Lumber & Fluming Company switchback trestlework some 50 years ago. Another generation of dedicated researchers—Richard C. Datin Jr., Michael A. Collins, Charles D. Siebenthal, Dale B. Darney, Thomas B. Smith, and Kent K. Kristiansson—have since joined in keeping all of us immersed in primary source materials.

The staff of several institutions have been repeatedly generous in making their collections available, including the Bancroft Library, the Henry E. Huntington Library and Art Gallery, the California State Railroad Museum, Lake Tahoe Historical Society, Special Collections at the University of Nevada-Reno Library, Nevada Historical Society, the Nevada State Museum, and the Nevada State Railroad Museum.

Conversations and correspondence over the years was also invaluable to the research in hand with Grahame H. Hardy, David F. Myrick, William W. Bliss, William A. Oden, Christopher C. de Witt, Harry R. Kattelmann, and the late Edward R. Yerington, great-grandson of Henry M. Yerington.

I am particularly grateful for the generosity and kindred esprit de corps of colleagues Kyle K. Wyatt of the California State Railroad Museum and Wendell W. Huffman of the Nevada State Railroad Museum. Without these dedicated museum curators, this work would not have been possible.

Unless otherwise noted, the pictures and historical documents are from the collection of the author.

INTRODUCTION

The Big Lake, the Lake of the Sky, and the Gem of the Sierra—the names themselves conjure up something of the enormous grandeur and majesty of vast Lake Tahoe. Perched atop the northern Sierra Nevada at 6,225 feet above sea level, Lake Tahoe and its surrounding mountains and valleys are the results of millions of years of geologic evolution. The resulting lake is 21.2 miles long, 11.9 miles wide, 75.1 miles in circumference, and 1,645 feet deep, making it the third-deepest lake in North America.

For several thousand years, Lake Tahoe was the home to Washoe Indians during the snowless seasons of the year. In February 1844, John Charles Frémont and his second government expedition of some 40 men became the first Americans known to view the pristine lake.

The Mormons settled in western Nevada in the 1850s, but the real stampede to the area did not occur until the Comstock Lode, one of the world's greatest gold and silver mining camps, was discovered east of Lake Tahoe in 1859. The paying ore was not accessible by simple panning but required hard rock, underground mining with significant corporate investment, large quartz-reduction mills, and wage-earning miners. As the subsurface mining works descended to several thousand feet, "rooms" of pine timbers were left to shore up the earth where tons of rock had been extracted.

All manner of forest products was in demand. The mining companies used 12- and 14-inch square timbers to shore up the earth deep under the communities of Virginia City and Gold Hill. Building lumber was needed for the commercial buildings and residences of the nearly 40,000 Comstock inhabitants. The mine hoisting works and many of the early reduction mills were steam-powered and they had an insatiable appetite for cordwood as boiler fuel. The first "bonanza" was in full swing by the time Nevada became the 36th state in October 1864.

The nearby forests of the Carson Range supplied most of the timber, lumber, and cordwood consumed during the 1860s. But heavy snows made the harvesting of timber a seasonal operation. Roads for wagons and teams of oxen became almost impassable during wet months. The 1869–1872 construction of the 52-mile-long Virginia & Truckee Railroad (V&T) between Reno on the Truckee River, the new state capital at Carson City, and Virginia City soon provided the needed transportation link. The V&T afforded a dependable and more economical mode for transporting vast quantities of wood products, mining machinery, and merchandise to the Comstock. On the return trips, the V&T transported the extracted ore to the nearby steam- and water-powered quartz mills. The demand for timber products was never-ending, going on 24 hours a day. But the forests of the Carson Range were soon exhausted, and the French Canadian lumberjacks began eyeing the vast forests of giant pine trees surrounding Lake Tahoe. The lake basin would become an invaluable timber resource for continuing exploration of the Comstock Lode.

Maine lumberman Capt. Augustus W. Pray built the earliest large sawmill on the lake at Glenbrook in 1861. In November 1873, V&T general superintendent Henry Marvin Yerington, former Gold Hill banker Duane LeRoy Bliss, and Glenbrook mill superintendent James A. Rigby

organized the Carson & Tahoe Lumber & Fluming Company (C&TL&F). The trio borrowed money from Bank of California financier Darius Ogden Mills and others. They acquired Captain Pray's mill, several other sawmills in the vicinity, and the company's initial 7,000 acres of timberlands along the lake's south shore. Lake Tahoe was about to see its first big-time logging operations and it earliest railroads.

The C&TL&F's Lake Tahoe Narrow Gauge Railroad began operations in 1875 from the sawmills at Glenbrook up to Spooner Summit and the head of the Clear Creek wood flume running down to the V&T yards at Carson City. The C&TL&F was the largest operator at Lake Tahoe, and it spawned affiliated and competing wood, lumber, and railroad ventures around the lake. Matthew C. Gardner had a short standard-gauge railroad at Camp Richardson, as part of a contract to harvest logs for Yerington and Bliss. G.W. Chubbuck had a rail line at Bijou, on Tahoe's south shore, and a contract to deliver logs to the C&TL&F Company. The two contractors' railroads delivered logs wherever they could be rolled into Lake Tahoe, chained together into log booms or barges, and then towed by C&TL&F steamboats across the lake to the company's sawmills at Glenbrook.

The second major company supplying the Comstock was the Sierra Nevada Wood & Lumber Company (SNW&L) controlled by Walter S. Hobart, Samuel H. Marlette, and other investors at Crystal Bay, on the northeast shore of Lake Tahoe. The SNW&L had a sawmill, narrow-gauge and incline railroads, and a "V" flume running down to Lake View on the V&T.

The third major timber enterprise in the area was the Pacific Wood, Lumber, & Fluming Company (PWL&F) controlled by Comstock "Bonanza Kings" John W. Mackay, James G. Fair, James C. Flood, and William S. O'Brien. Operating just northeast of Lake Tahoe, the PWL&F had a sawmill and flume that delivered timber products trackside at Huffakers on the V&T from 1875 to 1880. The company did not have an independent railroad, although it did threaten to build its own narrow-gauge line.

The harvesting of heavy timbers predated serious environmental concerns for the lake and the surrounding forests.

With every boom, there is an inevitable bust. By the late 1890s, the first-growth timber resources of the Tahoe Basin were nearly exhausted and the Comstock's high-paying ore had largely petered out as well. Even during the heavy mining period, Lake Tahoe was a popular summer and tourist destination that was renowned for its peacefulness and beauty. In the mid-1890s, C&TL&F president D. L. Bliss concluded to "retool" the company's railroad and steamboats from hauling wood products to handling passengers and tourists.

The Lake Tahoe Railway & Transportation Company (LTRy&T) was incorporated by Bliss and his family in December 1898, and they purchased the locomotives and track assets of the C&TL&F. The new LTRy&T's 15-mile narrow-gauge line opened in May 1900 to ferry summer passengers from Truckee, California, on the Southern Pacific (SP), to Tahoe City, the imposing Tahoe Tavern, and out onto a 954-foot-long wharf for close connections with the famous SS *Tahoe*. Operated initially during the six-month tourist season, the narrow-gauge line flourished for nearly two decades until the rise of private automobiles and increased highway competition.

The Bliss family leased the railroad to Southern Pacific (SP) in October 1925, and SP began a major campaign to attract year-round traffic to the Truckee–Tahoe City "Lake Tahoe Route." Once ownership was acquired, the tracks were widened by SP to standard gauge effective May 1926. Railroad operations continued until 1942 when all freight and passenger traffic was suspended. There was a brief steam tourist operation at South Lake Tahoe beginning in 1970. There has been talk for years of a South Shore trolley using old San Francisco Municipal Railway cars, but nothing has materialized in the way of new rails.

Railroad operations in the Lake Tahoe Basin extended from 1875 to 1942. Today, Mother Nature has reclaimed most of the evidence of 67 years of railroad operations around the majestic lake. Only a few artifacts and photographic documentation remain as tangible evidence of the once great railroad enterprises that touched every shore—north, south, east, and west—of what many consider "the Grandest Lake in America."

One

THE LAKE OF THE SKY

Lake Tahoe is the undisputed grand lake of the Sierra and the largest alpine lake in North America. It is encircled by a panorama of mountains towering as much as 4,500 feet above the surface of the water. The surrounding mountains and the 191-square-mile water surface capture the snow that feeds the pristine lake. Melted snow makes for an extremely cold lake, but the vast body of water never freezes. The lake's surface temperature varies from 41 to 68 degrees Fahrenheit. The Truckee River is the lake's only outlet. The Truckee runs through Reno and into Pyramid Lake, Nevada, which has no outlet. Only one-third of the water that leaves the lake departs via the Truckee River, while the rest evaporates from the vast surface of the lake.

The historical clarity of the mountain water is legendary, with a white dinner plate still visible at a depth of nearly 100 feet.

On the heels of the Gold Rush of 1848 and 1849, California became the 31st state in 1850. With two-thirds of the lake located in California, state explorations the next year named the body of water Lake Bigler in honor of California's third governor, John Bigler. But in 1862, the US Land Office stepped in and approved restoring the Indian name Tahoe (pronounced "ta' ho"), which loosely means "sea" or "lake water."

Until 150 years ago, thousands of acres of dense, native pine forests encircled the lake. The principally Jeffrey pines were eight to ten feet in diameter and achieved heights of 100 to 150 feet. Wholesale harvesting of the pine monarchs in the late 19th century left the present relatively even forest of second-growth trees in all but a few areas around the lake.

Lake Tahoe has been a destination for visitors for more than 150 years, offering outstanding opportunities for boating, swimming, fishing, camping, picnicking, hiking, horseback riding, winter sports, and a host of other resort and recreational activities. The popularity of the majestic mile-high lake shows no signs of waning.

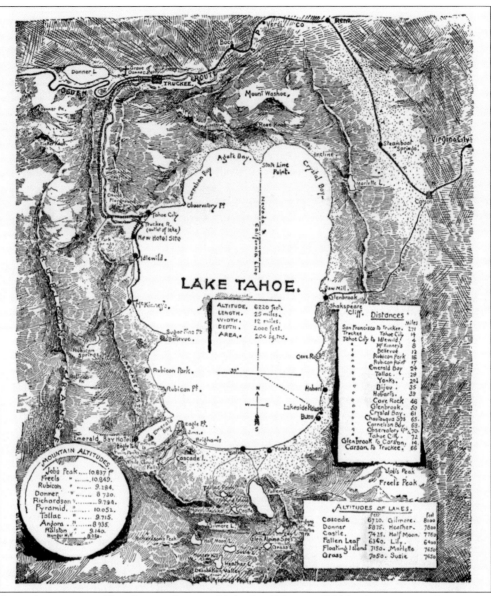

An early promotional brochure and map published in February 1900 by the passenger department of the Southern Pacific Railroad encourages a visit to Lake Tahoe via a stopover on the SP at Truckee, California, and "the newly completed narrow-gauge railway of the Lake Tahoe Railway & Transportation Company" to Tahoe City. "Lake Tahoe! A liquid mountain mirror! A lake six thousand feet above the sea! A lake so vast that a steamer travels 72 miles to skirt its shores, and so blue that you will be tempted to dip your pen in and almost expect to spread its color like blue ink upon your writing paper." (Southern Pacific Company.)

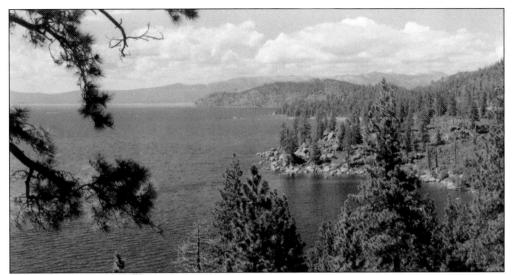

The Nevada shore of Lake Tahoe includes more than 25 miles of both beaches and rugged shoreline. Prominent along the Nevada shore in the late 19th century, in this view looking north from left to right, are Crystal Bay, Incline, Glenbrook, Shakespeare Rock, Cave Rock, and Zephyr Cove. Today, the vista is still just as awe-inspiring.

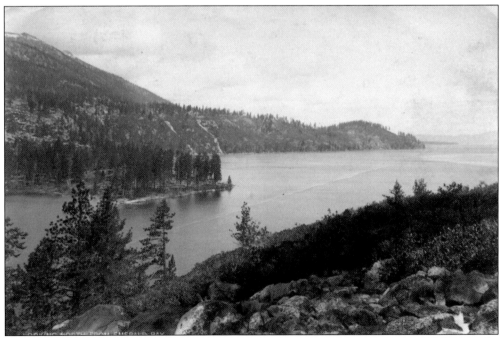

In a view looking north, Emerald Bay opens into Lake Tahoe. Located on the California side, the bay is a sheltered inlet off the southwest portion of the lake. Known as the "most beautiful inland harbor in the world," the landlocked oval is fed by snow water and can occasionally freeze. Surrounded by pines and cedars, Emerald Bay has variously been the home over the past 150 years to human hermits, camps, resorts, hotels, and palatial private residences.

"The grandest mountain lake in America is Tahoe, ranking all others in rare beauty, fine scenic effects and climate" is how full-page Virginia & Truckee Railroad ads in H.S. Crocker & Company's monthly *Railroad Gazetteer* promoted Lake Tahoe. In the late 19th century, the most popular route to the lake was via Jim M. "Doc" Benton's daily stages, which barreled up King Street from the state capitol in Carson City to Glenbrook on the east shore. Stage tickets were sold at Carson City, at Truckee, California, and at Central Pacific Railroad ticket offices from San Francisco to Ogden, Utah. (California State Railroad Museum.)

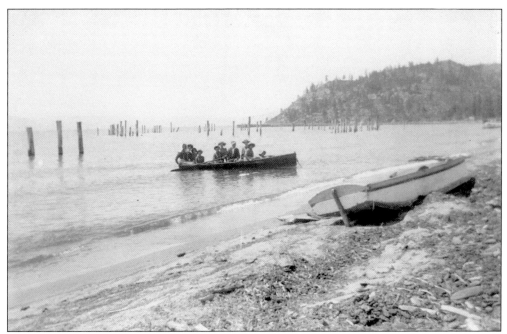

Boating was a popular pastime at Lake Tahoe, documented here amongst the old pier and log booms at Glenbrook. There were many summer boating choices between the large lake steamers, yachts, small sailboats, or just a simple rowboat for the entire family to pile into. Launch trips were encouraged, "both by day and by moonlight."

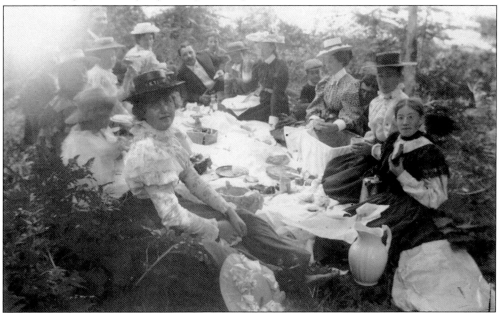

Day picnicking was always a favorite pastime at Lake Tahoe. A spread, cloth napkins, china, silverware, and a bottle or two of wine were standard fare. The young woman at left has set aside her flowered hat for a more traditional one from the SS *Tahoe*. Tahoe resort brochures from the time advertise "Picnic lunches furnished free to guests. Absolutely no rattlesnakes, poison oak, or poisonous insects."

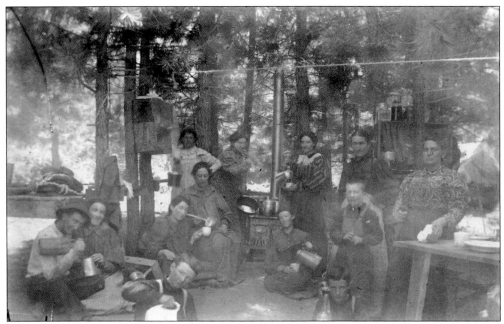

What could taste better than freshly brewed early-morning coffee, while camping lakeside at 6,225 feet above sea level? Impromptu tents provided changing and sleeping accommodations for the ladies. Cooking, eating, and most all other activities were carried out al fresco in crisp mountain air among the pines.

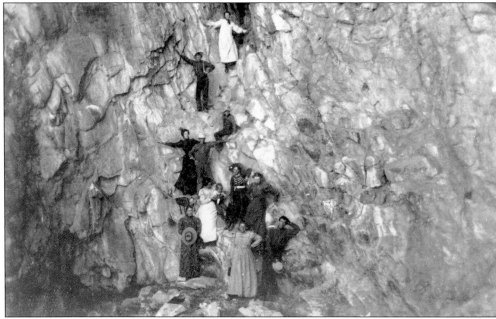

Cave Rock is located on the eastern shore of Lake Tahoe between Zephyr Cove and Glenbrook. The rock is a 360-foot core remnant of a volcano that erupted some three million years ago. Cave Rock has long been a site for climbing, despite being considered as sacred by many Washoe Indians. Twin highway tunnels were bored through the rock in 1931 and 1957, destroying much of the original cave.

Lake Tahoe has historically boasted miles of hiking and equestrian trails, creating an intergenerational activity for all ages. Stables with horses for hire were located all around the lake. Overnight camping trips were available to higher elevations for hunting and fishing. Rugged hiking and then catching one's breath are not for the faint of heart amidst the thinner air of elevations 6,200 feet and above.

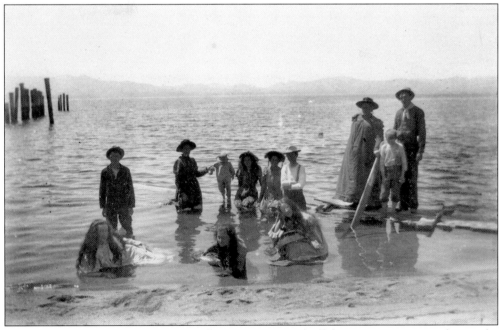

Beach bathing at Glenbrook was an effective way to cool off during warm summer days at the lake. Promotional brochures from that era suggest, "It is advisable to bring your own suit, although suits may be had at the camp." If people did not bring their bathing suits, it was no problem. They would wade in as they were—hats and all.

Thirty-nine silversides were once an easy day's catch in Lake Tahoe. Commercial fishing in the lake dated from 1859 for native cutthroat trout of often 20 to 30 pounds each plus larger "mammoths." Nonnative Mackinaw and other trout varieties were introduced starting in 1895, along with salmon beginning in 1944.

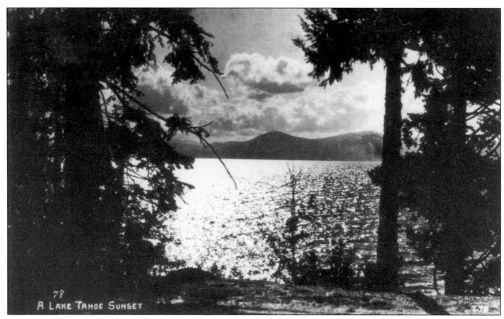

Second-growth pine trees frame the nostalgic vista across the lake as the late-afternoon clouds gather and the setting sun drops behind Lake Tahoe's western Sierra. A promotional ad from 1886 advises, "The wonderful summer sunsets of Tahoe, with their great wealth of coloring, are alone worth a visit."

Two

THE COMSTOCK'S
DEMAND FOR WOOD

A decade after the California Gold Rush of 1848–1849, miners discovered "blue stuff" over on the east side of the Sierra Nevada. The "blue stuff" turned out to be silver, and the rush was on to Washoe. The discovery on the eastern flank of Mount Davidson led to one of the greatest mining camps in the world. In the 20-year period from 1860 to 1880, the Comstock Lode produced an unparalleled record of $300 million in silver and gold. The principal communities of Virginia City and Gold Hill were still producing more than a million dollars a year through 1894.

But it was a different kind of mineral rush. It was not every man for himself, individually panning in streams for nuggets of gold. Instead, it was hard-rock mining organized by mining companies that built large hoisting works, employed scores of hardworking miners, and excavated ore from hundreds–eventually, a couple thousand feet—below the surface of the earth. The investment in the physical plant was substantial, with huge furnaces, boilers, and hoisting works. Wildly speculative investors bought and sold the mining stocks on the streets of San Francisco.

The Comstock Lode had an insatiable appetite for all types of timber products. Philip Diedesheimer's square-set timbering process left entire "rooms" of underground timbers where ore was shoveled out by hand. Construction lumber was desired by the hoisting works, local merchants, and for the residences of the nearly 40,000 inhabitants. Cordwood was in demand for heating and fueling the furnaces of the mining and milling equipment. At its peak, the Comstock was consuming nearly 80 million board feet of lumber and two million cords of firewood each year.

In the early 1870s, the new Virginia & Truckee Railroad helped meet the wood demands of the Comstock. The V&T hauled wood products up the hill, and on the return trip, the railroad delivered ore to the quartz-reduction mills for processing. Trackside wood flumes extended increasingly westward towards Lake Tahoe to reach still new stands of virgin timber forests. The Comstock had a seemingly never-ending demand for wood.

The combination Chollar, Norcross, and Savage Shaft is in the foreground of this c. 1877 view looking north through Virginia City. Hoisting works, churches, saloons, schools, businesses, bars, and residences stood side by side in the overnight metropolis. In the mid-1880s, the Combination Shaft reached a depth of more than 3,000 feet, making it one of the largest and deepest mining shafts in the United States. (Photograph by Carleton E. Watkins.)

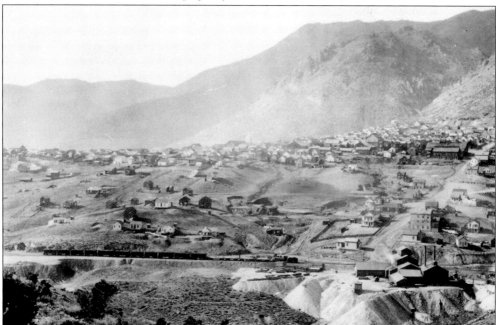

In the foreground of "the Divide" between Virginia City and Gold Hill, a diminutive V&T freight locomotive handles a string of flatcars, including 11 carloads of cordwood. In the right foreground is the famed Julia Mine, which levied $1,361,000 in assessments but never produced any paying ore. The mine was reportedly named for famed Comstock courtesan Julia C. Bulette. (Photograph by Carleton E. Watkins.)

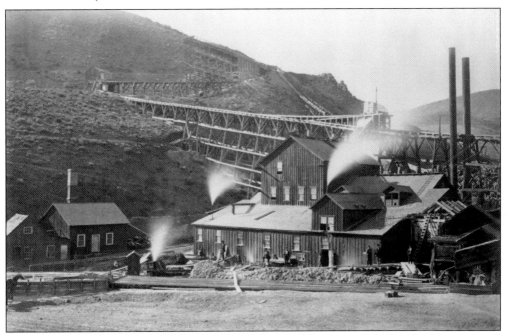

The Trench Mill at nearby Silver City was one of several dozen wood-fired mills that processed both silver and gold ore. A series of tramways delivered ore to the Trench and neighboring mills. The huge pile of cordwood behind the tramway trestlework on the right was delivered via a wood chute from the V&T's Silver City branch located on the hill above. (Photograph by Carleton E. Watkins, courtesy California State Library.)

The Virginia & Truckee had several wood rack cars for delivering cordwood to its remote stations, section crew facilities, and fueling locations along the 52-mile main line. The 29.5-foot-long cars each weighed about 17,500 pounds and held 10 cords of woods. In the 1870s and 1880s, a typical V&T locomotive averaged about 20 miles per cord of wood. (Paul B. Darrell Collection, California State Railroad Museum.)

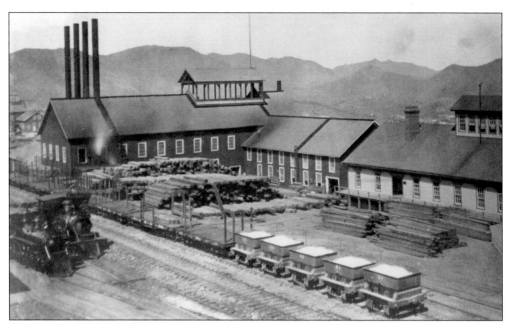

Pacific Coast photographer Carleton E. Watkins captured this c. 1877 scene along the E Street yard of the Consolidated Virginia Mining Company. Twelve- and fourteen-inch square-set timbers have been off-loaded from the V&T flatcars. Several piles of building lumber are stacked between the loaded V&T ore cars and the Consolidated Virginia's assay office on the extreme right. (Mackay School of Mines.)

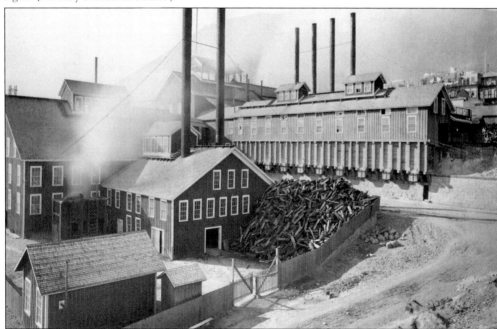

Behind the Consolidated Virginia on F Street was the mine's 60-stamp quartz mill, which was built at a cost of $450,000 by the "Bonanza Firm" of John Mackay, James Fair, James Flood, and William O'Brien. The huge pile of cordwood was delivered by the V&T and is just outside the open doorway to the boilers that powered the steam-driven works. (Photograph by Carleton E. Watkins.)

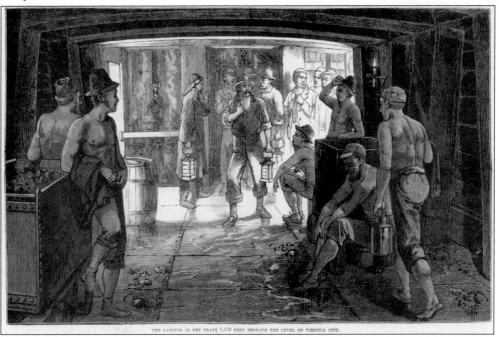

Frank Leslie's Illustrated Newspaper of March 9, 1878, includes two underground scenes in the Consolidated Virginia—the largest precious metal producer on the Comstock. In the vertical image, miners are lowered into the timber-lined shaft for their eight-hour shift that paid $4 per day. Below, shirtless miners take a break from the intense underground heat amidst timber-laden "rooms" made from forests of Sierra timbers. The massive quantities of Comstock lumber comprised a virtual tomb of the Sierra forest.

NEVADA.—DESCENDING THE SHAFT OF THE CONSOLIDATED VIRGINIA SILVER MINE, IN VIRGINIA CITY.

THE LANDING IN THE SHAFT 1,550 FEET BENEATH THE LEVEL OF VIRGINIA CITY.

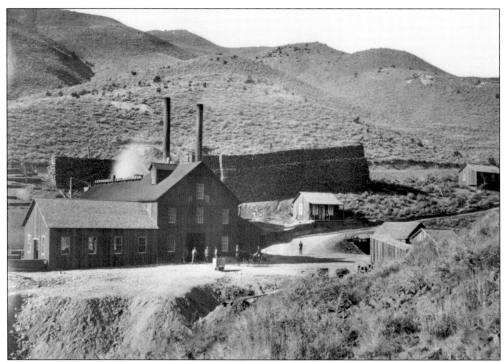

Walls of cordwood fueled the boilers and hoisting machinery of hundreds of mines, like the Florida Hoisting Works, throughout the Comstock Lode. The Florida mine was located in Lyon County, two miles west of Silver City, along American Flat Road. A steady supply of cordwood allowed the mine to remain active in the 1870s. Unfortunately, the Florida never produced any paying ore. (Photograph by Carleton E. Watkins.)

As evidenced by the nearly three cords on No. 17's tender at Washoe in 1905, V&T steam locomotives were also a major consumer of wood fuel. In the 1870s, the V&T's 24 engines devoured nearly 2,000 cords per month. In 1911, the 2-6-0 No. 20 *Tahoe* was the last V&T locomotive to be converted from cordwood to burning fuel oil. (Photograph by Stanley G. Palmer.)

Three

THE LAKE TAHOE NARROW GAUGE

French Canadian entrepreneur Henry M. Yerington arrived in Nevada in 1863 and soon had a controlling interest in the Merrimac quartz-reduction mill located along the Carson River. In 1868, Yerington became a partner in the Summit Flume Company, which had a sawmill near Spooner Station and eventually a 12-mile flume down toward Carson City. A shrewd Republican, Yerington quickly aligned himself with the Bank of California's interests in the Comstock, the Union Mill & Mining Company, and the Virginia & Truckee Railroad. In 1870, Yerington and colleague Duane Bliss formed Yerington, Bliss & Company and they subsequently purchased the Summit Flume Company. The "& Company" was silent partner Darius Ogden Mills, who bankrolled the ventures of Yerington and Bliss with sizable loans at the then-prevailing rate of one percent per month.

As the forests of the Carson Range became exhausted, Yerington and Bliss looked farther west to the large pine forests surrounding Lake Tahoe. In November 1873, they formed the Carson & Tahoe Lumber & Fluming Company (C&TL&F) with headquarters and sawmills at Glenbrook, Nevada. In 1875, they built the 8.75-mile Lake Tahoe Narrow Gauge Railroad from Glenbrook up to Spooner Summit, along with 2.5-miles of spur tracks. They used the Summit Flume to float lumber down to the vast woodyard served by the Virginia & Truckee below Carson City. According to Bliss, the venture was begun for the railroad but William Sharon encouraged Yerington and Bliss to "take hold of the business for themselves, and they did so." Bliss became C&TL&F president and built his family a home at Glenbrook, while Yerington remained at Carson City as general superintendent of the V&T. Mills bought in after three years and eventually owned more than 10,000 shares of C&TL&F stock.

The C&TL&F became the largest logging company operating in the Tahoe Basin. According to Bliss's figures, the company owned 50,000-plus acres of timber land at Lake Tahoe, including more than one-third of the shoreline. By 1887, the company had cut over 500 million feet of lumber and "flumed" it to Carson City. The Lake Tahoe Narrow Gauge Railroad was the critical link in transporting cordwood, mining timbers, and building lumber from the lakeside mills at Glenbrook up 900 feet in elevation to the top of Spooner Summit.

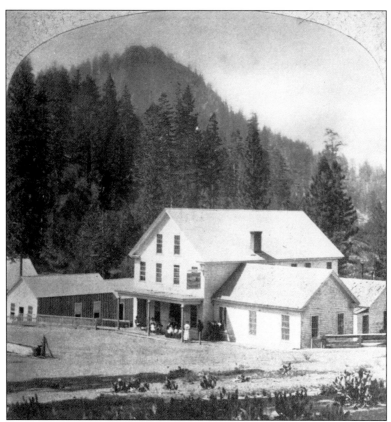

The starting point for the Lake Tahoe Narrow Gauge was Glenbrook on the east-central shore of Lake Tahoe. The community derived its name from the Glen Brook House, which was located by a brook in a glen near Shakespeare Rock. The popular hostelry served the rich and famous. In the late 1800s, the resort hotel was charging guests $3 a day for deluxe accommodations. (Yerington family collection.)

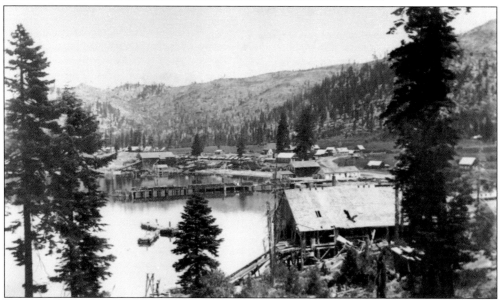

In the mid-1880s, Glenbrook Bay was a busy sawmill community for the C&TL&F. In this view looking north along the shoreline is Capt. Augustus W. Pray's early sawmill in the foreground, then the Glenbrook pier and overwater store and warehouse, and finally, the C&TL&F's Sawmill No. 2. Mill No. 1 is behind the pines trees on the left. (Photograph by R.J. Waters.)

The Lake Tahoe Narrow Gauge Railroad was known by many names throughout its short 25 years. It was a private industrial railroad, wholly within the state of Nevada, and not operated for passenger service. Its locomotives never bore the name of the railroad or parent copy. An early display ad submitted by the V&T appearing in the July 1874 issue of the *Official Guide of the Railways and Steam Navigation Lines of the United States* calls the line the Carson and Tahoe Railroad. (California State Railroad Museum.)

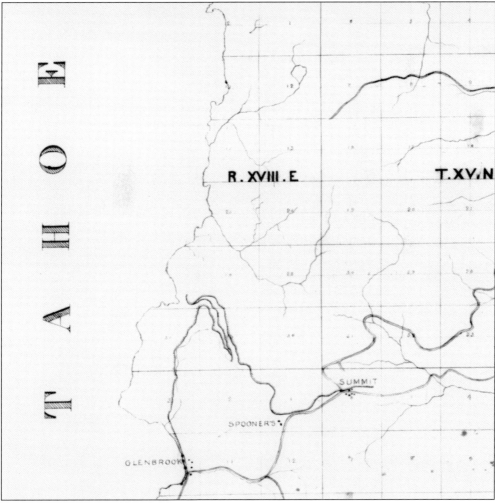

V&T chief engineer Charles L. Anderson labeled this 1876 map the Lake Tahoe Narrow Gauge Railroad. The three-foot gauge, 35-pound rails ran from behind the Glenbrook sawmills, through Lower Pray Meadows, across 11 trestles, up a 2.3 percent grade through upper and lower switchbacks, through a 475-foot-long tunnel, and ended in the Summit flume yard. (Grahame H. Hardy collection.)

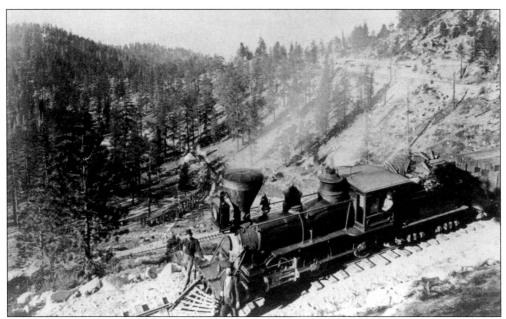

Carleton Watkins lugged his 15.5-by-21-inch glass-plate camera onto the narrow gauge around 1877 to provide stunning panoramas of the switchback lines as he zigzagged his way up to Summit. The 8.75-mile ascent took about an hour for one of the road's two locomotives pulling five to six 10-ton capacity flatcars. The first two engines were assigned the names *Tahoe* and *Glenbrook*. The name *Tahoe* is visible on the locomotive (above) as it pulls a load of 14-inch square-set mining timbers towards Summit. In the lower distance is the *Glenbrook* with a string of empties returning to its namesake. A six-car train of cordwood (below) heads towards Spooner Summit while a five-car train of timbers and lumber backs its way between the two mountain switchbacks. The silhouette of Watkins's huge camera is visible in the foreground. (Both photographs by Carleton E. Watkins.)

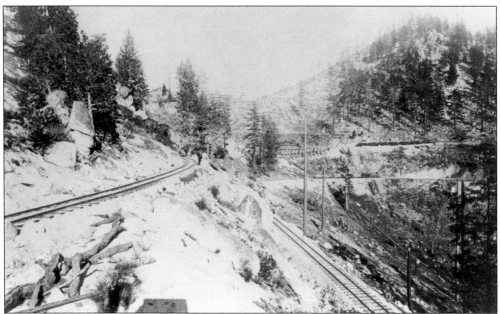

Chicago Station, *May 2* 1877

D. L. Bliss Reno Nev.

To CHICAGO, BURLINGTON & QUINCY R. R. CO., Dr.

For Freight from *Chicago to Bluffs*

Date of Way-Bill	No. of Way-Bill	NO. CAR.	WHOSE CAR.	DESCRIPTION OF ARTICLES.	WEIGHT.	RATE.	BACK CHARGES.	OUR CHARGES.
2	759	4169	B.O.	1 Tender, 1 Stack, 1 House, 1 Pilot 12 Tires 8 Axles 1 Snow Plow	20800	Cwt 25%		59 28
"	"	13	B.P.W.	1 Locomotive Boiler Fixtures 1 ash pan - 3 Bxs Machy. 20 Wheels	43000	28½	283 94	122 55
					63800		283 94	181 83

Copy by 15/77

Received Payment, _____ Agent

Consignor, B&O R.R. Phila via Bellair

Completed by Burnham, Parry, Williams & Company's Baldwin Locomotive Works in April 1877, C&TL&F Locomotive No. 3 was shipped dismantled on two flatcars from Philadelphia to Carson City. This made the job easier to haul the engine and tender by teams and wagons from Carson City up to the Lake Tahoe Narrow Gauge Railroad's shops at Glenbrook for reassembly.

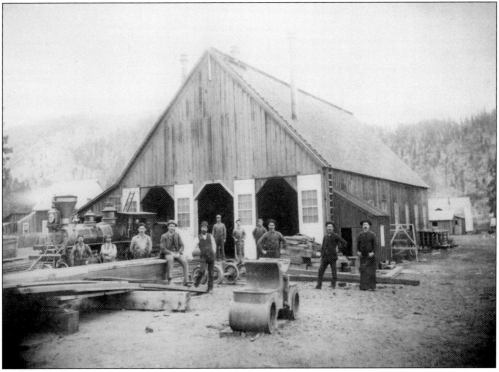

The Lake Tahoe Railroad was a one-way operation with loads of timber, lumber, and cordwood going up the mountain and empty flatcars coming back down. The line was also a seasonal "daylight" operation with the locomotives stabled overnight in the road's three-stall enginehouse at Glenbrook. In the foreground sits a two-piece iron casting for locomotive cylinders. (Photograph by George D. Stewart, courtesy Nevada State Railroad Museum.)

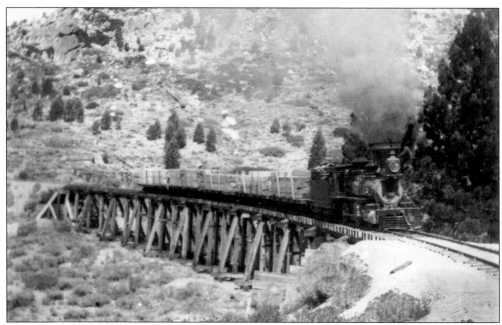

George Davidson Oliver was a 50-plus- year veteran lumber manager in the Lake Tahoe–Truckee River Basins. As a C&TL&F sawmill foreman at Glenbrook, the young Oliver often brought along his four-by-five-inch camera to document seemingly everyday events in the early 1890s. An engine and five cars (above) begin the ascent through Upper Pray Meadows toward the first switchback on June 25, 1891, at a speed of 10 miles per hour. The twin narrow-gauge engines are on the high side of the second switchback in Slaughter House Canyon (below) in late October 1893. The engineer of the *Tahoe* looks back toward a derailed flatcar in his consist while 2-6-0 No. 1 (left) comes alongside "light," without any cars, to assist with the rerailing effort. (Both photographs by George D. Oliver.)

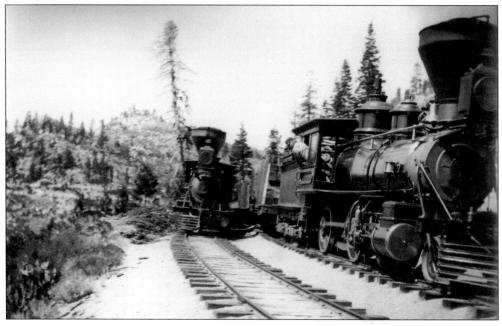

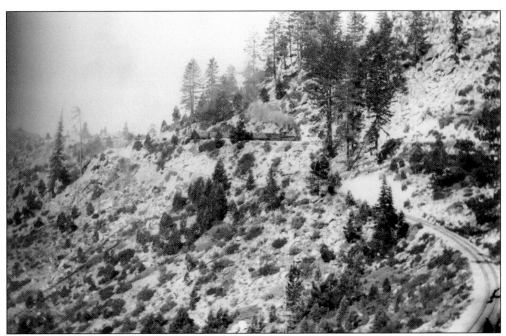

A train load of cordwood (above) makes its final assault on Spooner Summit. The train has just left the second switchback with its stub-end trestle and spectacular view of Lake Tahoe from 500 feet above the water. The conductor and a brakeman are atop the six-car train of 30,000 pounds of cordwood (below) as it moves "at speed" in 1893 across a trestle, out of Slaughterhouse Canyon north of Glenbrook, and toward the first of the two switchbacks. The photographer loaded his own film and personally developed these remarkable images of action trains moving under steam during 1891 to 1893. (Both photographs by George D. Oliver.)

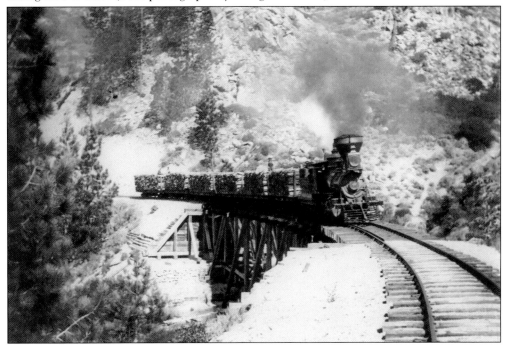

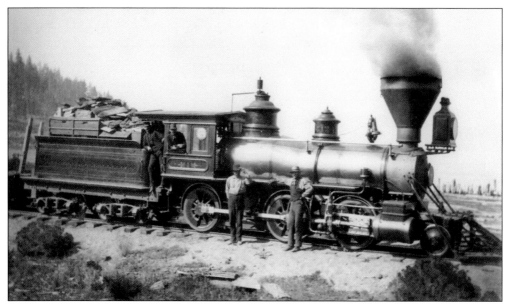

The order for the C&TL&F's narrow gauge 2-6-0s, or "moguls," was entered by the Baldwin Locomotive Works of Philadelphia on December 18, 1874, for two identical wood-burning locomotives. The engines were originally ordered with the names *Summit* and *Glenbrook* and were assigned Baldwin's unique class numbers of 8-20 D Nos. 12 and 13, respectively. The *Summit* was changed to *Tahoe* prior to delivery. The engines were later assigned Nos. 1 and 2. (Photograph by George D. Oliver.)

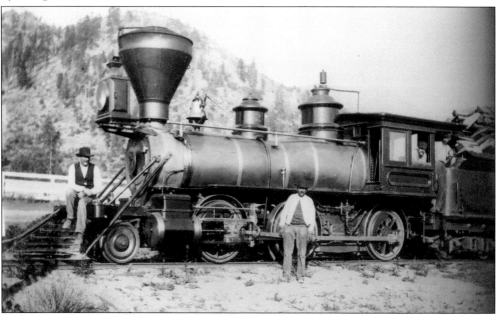

C&TL&F No. 2 was photographed in July 1892 on the main track at Glenbrook. Both locomotives had 40.5-inch diameter drivers, 23-by-16-inch cylinders, painted ash cabs, weighed 62,000 pounds, and had a working boiler pressure of 130 pounds and a tractive power of 7,290 pounds. Each locomotive cost approximately $8,000. Upon arriving at Glenbrook in June 1875, both locomotives were used to help construct the new railroad. (Photograph by George D. Oliver.)

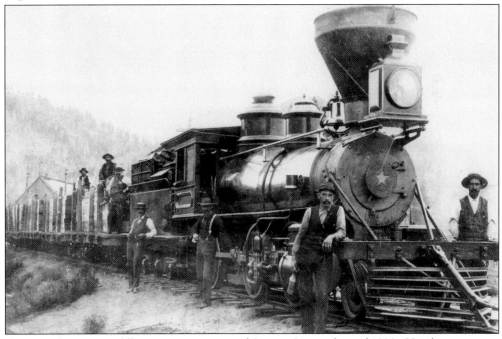

PayRoll *L T N & R R* of the ~~Carson & Tahoe Lumber & Fluming~~ Co. *for the Month of* Oct *A.D.1881*

NAME.	Total No. of Days.	Wages per Day.	OCCUPATION.	Amount Due.	Total Amount.	RECEIVED PAYMENT.		
Jno Rogers	1	one		month		200	Jno Rogers	1
R M Lee	2	35½	4	Cond	142	133 34	R M Lee	2
Wm McCluen	3	35½	3 25	Brak	115 37	106 71	Wm McCluen	3
John Tait	4	35½	5	Eng	177 50	168 84	J F Tait	4
R Doran	5	29½	3 50	Fire	104 12	95 16	Bob Doran	5
F Borton	6	5½	3 50	"	20 12	20 12	F Borton	6
John Charles	7	34½	4	Cond	138	133 34	J Charters	7
C Searll	8	20½	3 25	Brak	66 8	13 08	Searl	8
O Glancey	9	14½	3 25	"	46 31	41 98	Owen Glancy	9
D Follett	10	34½	5	Eng	172 50	164 84	David Follett	10
Wm Cranmer	11	34½	3 50	Fire	120 75	113 09	Wm Cranmer	11
P Mansfield	12	26½	4 25	Foreman	112 62	112 62	P Mansfield	12
P Donovan	13	26½	3	Lab	79 50	79 50	Pat Donovan	13

The payroll of the Lake Tahoe Narrow Gauge Railroad totaled $1,795.42 for its 18 employees in October 1881. John T. Rogers earned $200 a month and had succeeded famed V&T engineer John Bartholomew as the narrow gauge's second superintendent. The monthly payroll included engineers, firemen, brakemen, conductors, a "roadmaster," section crew, and laborers.

Photographer R.B. Middlemiss was active out of Carson City in the mid-1890s. His classic portrait of the enginehouse lead at Glenbrook has the engineer, fireman, and conductor posed around the 2-6-0. C&TL&F superintendent Charles Tobey Bliss leans against the tender deck while rear brakemen prepare to keep the six loaded cars under control in an operating era prior to air brakes. (Photograph by R.B. Middlemiss.)

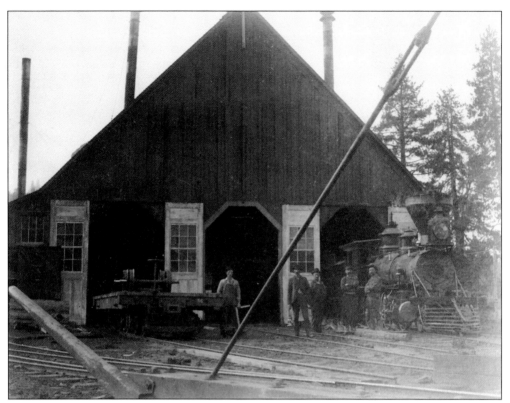

Locomotive crews performed light maintenance in the Glenbrook enginehouse during winter months and when they were not otherwise out on the road. The impressive peaked enginehouse roof was designed to minimize the impact of winter snow. In the foreground is one of the two manually operated gallows-type turntables located at each end of the line for turning a locomotive. (Grahame H. Hardy collection.)

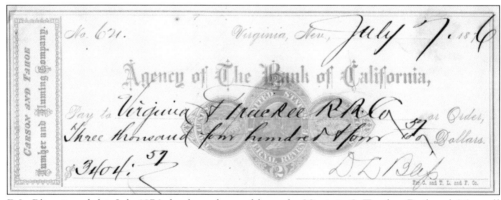

D.L. Bliss signed this July 1876 check made payable to the Virginia & Truckee Railroad. Most all of the C&TL&F's supplies were shipped by the V&T into Carson City and then handled by stage up to Glenbrook. The massive V&T shops also supplied parts for the sawmills and the railroad. Occasionally, V&T boilermakers and painters were sent up to Glenbrook to perform work.

Large numbers of Chinese crews cut cordwood from the top part of Lake Tahoe trees. The wood was then carried by 180-cord-capacity barges to Glenbrook, where it was loaded onto flatcars for the trip up to Summit. A C&TL&F train has backed onto the Glenbrook cordwood pier for loading. The early Comstock Lode had a never-ending appetite for cordwood fuel. (Nevada State Railroad Museum.)

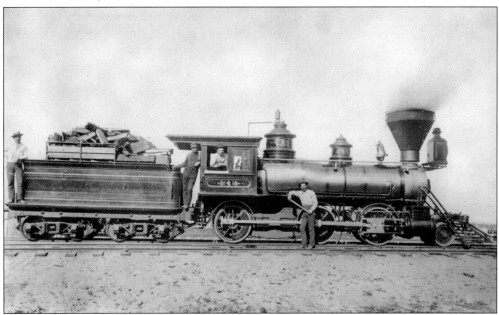

For a brief period, one of the narrow-gauge engines was rebuilt and renumbered "4." The locomotive's four-man crew poses in a classic engineer's side view. The tender has been loaded with 1.5 cords of pine slabs and the 1,000-gallon water tank is inclined slightly forward toward the engine's boiler. Watered and fueled at Glenbrook, the engine is ready for yet another trip to the summit. (Gilbert H. Kneiss collection.)

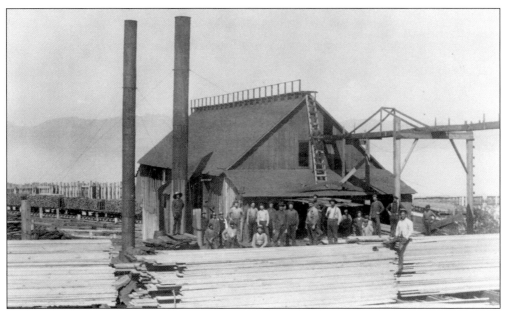

C&TL&F Mill No. 1 was built in 1873 under the supervision of superintendent James A. Rigby. Behind the mill at left is the cordwood loading track. H.M. Yerington advised D.O. Mills on October 12, 1887, that the old mill had burned due to a boiler fire and strong easterly winds. The loss was $12,500 along with three flatcars and a barge load of wood. This 1880s photograph was taken by George D. Stewart. (Nevada State Railroad Museum.)

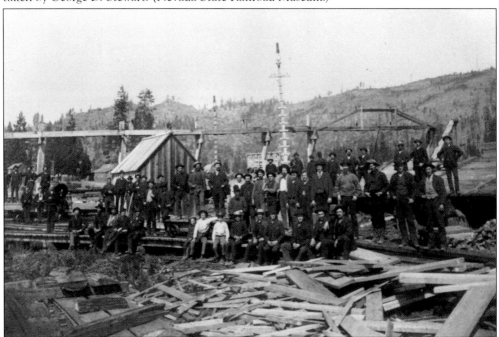

Overhead box flumes delivered cooling water to the saws on the east sides of the company's two mills at Glenbrook. At the peak of production from 1875 to 1887, the C&TL&F was producing 150,000 board feet of timber and lumber every day. This 1880s photograph was also taken by George D. Stewart. (Nevada State Railroad Museum.)

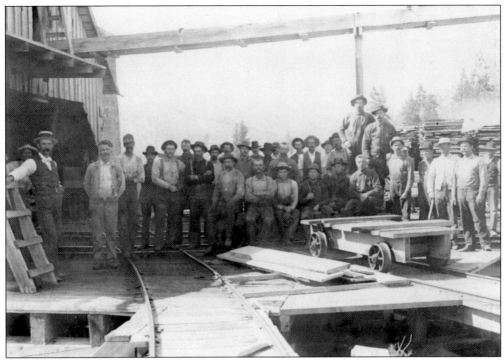

R.B. Middlemiss took this portrait of the crew at C&TL&F's Sawmill No. 2. In 1883, Mill No. 2 still employed 38 men. The company's third superintendent, C.T. Bliss, is in the white shirt and vest on the left. The rails in the foreground are for pushcarts that handled the freshly sawn timbers. (David F. Myrick Collection, Nevada State Railroad Museum.)

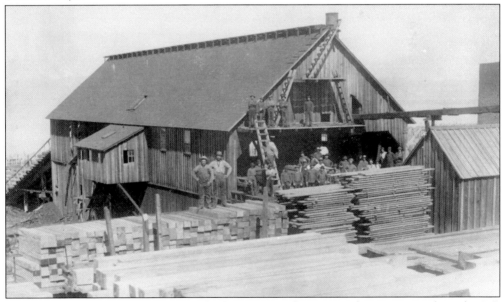

The C&TL&F's larger Mill No. 2 was built in 1875, and it remained in operation through 1897. The muscular and hearty employees stand proudly behind the day's production of mining timbers at left and building lumber on the right—and, of course, there was always lots of sawdust. (David F. Myrick Collection, Nevada State Railroad Museum.)

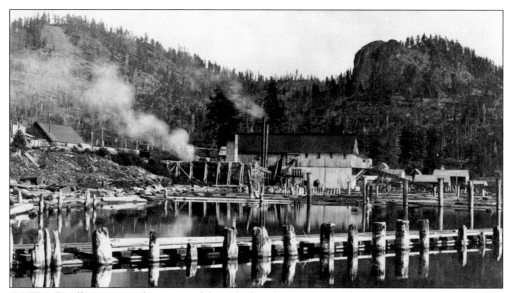

C&TL&F Mill No. 2 is in the center of this Glenbrook view, below Shakespeare Rock. The narrow-gauge spur in the foreground helps define the log pond for the mill. The high-peaked roof of the three-stall enginehouse is on the extreme left. The numerous poles and wires are for the electric lights that D.L. Bliss introduced at Glenbrook in late 1887. (Grahame H. Hardy collection.)

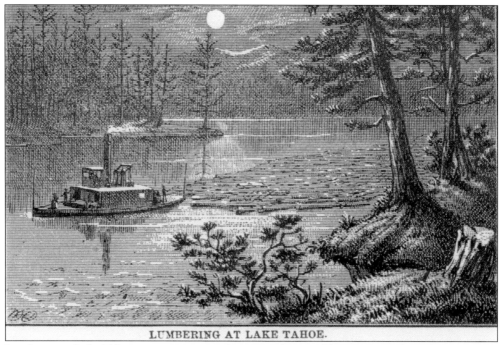

LUMBERING AT LAKE TAHOE.

Lumbering at Lake Tahoe is an engraving of towing a boom of logs across Lake Tahoe from the William Wright (pseudonym Dan DeQuille) book *History of the Big Bonanza: An Authentic Account of the Discovery, History and Working of the World Renowned Comstock Silver Lode of Nevada…* published in 1876. The profusely illustrated 569-page book is dedicated to John Mackay and contains an introduction written by Mark Twain.

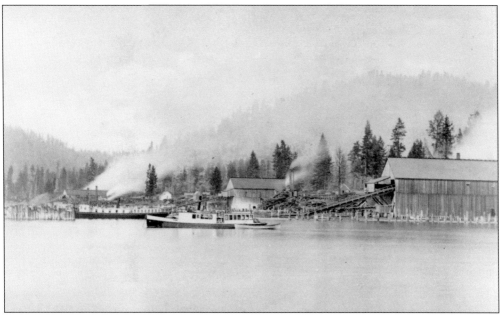

In addition to steam locomotives, the C&TL&F had a fleet of boats. In this view looking north across Glenbrook Bay is the 55-foot wood-hulled *Emerald I*, built in 1869 and purchased by C&TL&F in June 1874. The tugboat's boiler was condemned in 1881. Behind the *Emerald I* is the *Meteor*, amidst protective pilings. Left to right around the bay are the Glenbrook/Davis Mill and C&TL&F Mills Nos. 1 and 2. (Yerington family collection.)

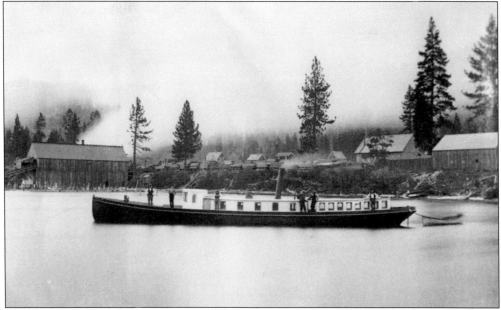

The nearly 80-foot-long iron-hulled *Meteor* was built in 1875 for the C&TL&F. Wood-fired, the steamer had a boiler built by the Baldwin Locomotive Works. The *Meteor*'s top speed was 20 knots at 200 pounds of boiler pressure, making it the fastest boat on the American continent at the time of its 1876 launching. The vessel was retired in 1928 and scuttled on Lake Tahoe in April 1939. (Yerington family collection.)

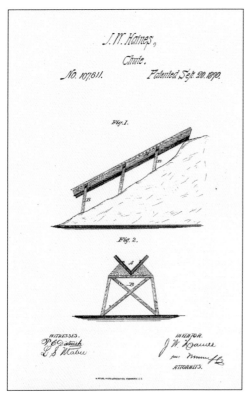

US Patent No. 107,611 was issued on September 20, 1870, to lumberman James W. Haines of Genoa, Nevada. This style of flume was lighter-weight and more successful for milled lumber over conventional box or U-shaped flumes. The "V" flume or chute was widely used from the mountains above Lake Tahoe down into the Truckee Meadows, and the Washoe and Carson Valleys. Water was the lubricant that floated timbers down the hillside at speeds of up to 60 miles per hour. At the peak of the Comstock Lode, more than 100,000 board feet of wood were flumed every day from Lake Tahoe forests down to the valleys and meadows below. The wood products were then hauled by wagons or the Virginia & Truckee Railroad up to Silver City, Gold Hill, and Virginia City.

Four

FLUMING BETWEEN RAILROADS

The Carson & Tahoe Lumber & Fluming Company's Summit Flume was the physical link between two railroads with a difference in elevation of almost 2,500 feet. The 12-mile long "V" flume connected the Summit woodyard of the Lake Tahoe Narrow Gauge Railroad (LTNG) with the standard-gauge woodyard served by the Virginia & Truckee Railroad just south of Carson City. The flume was part of an interwoven ownership that cut the wood, towed it to the Glenbrook sawmills, hauled it by rail to Spooner's Summit, flumed it down to Carson City, and then transported it via the V&T up to Comstock mines and mills, especially those in which the Bank of California had a financial interest. What might appear to some as a virtual monopoly was viewed by others as progressive private enterprise, working seamlessly to best serve its entrepreneurial ventures, interests, and customers.

In 1887, D.L. Bliss estimated the C&TL&F's physical plant at $1 million, including $300,000 for the narrow-gauge railroad and $300,000 in Lake Tahoe timberlands. Most of the odd-numbered land sections were purchased from the Central Pacific Railroad. The company's average cost of property was $6 per acre, although considerable land was acquired for but $1.25 to $2 an acre. Trees smaller than 10 inches in diameter were usually left in place to reforest the lands.

Carson City was the destination of the Summit Flume and the home of the C&TL&F general office and box factory. After the last "Big Bonanza" of 1875–1878, the Comstock Lode began a slow, downhill decline. The timber resources of the Tahoe Basin were becoming depleted. The C&TL&F concluded logging in 1898 and entered a new phase of "property management." Today, large portions of the company's once vast holdings are national forests, owned and managed by the US Forest Service.

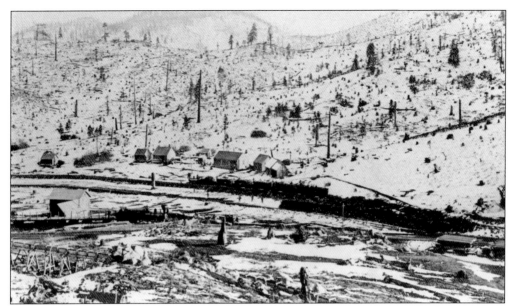

A C&TL&F locomotive (above) pulls six carloads of cordwood into the Summit yard around 1877. The steep-roofed pine shacks behind the train house the unloaders, timber-pushers, and flume men. A second locomotive in the foreground prepares to depart down the mountain with empty flatcars. The light dusting of snow makes it obvious that the hillside has already been denuded of much of its original pine forest. The *Tahoe* (below) heads up a train of 12 cars with the *Glenbrook* bringing up the rear. The gallows turntable at Summit is visible just above the *Glenbrook*. The trackside skid ways are used for off-loading the mining timbers and building lumber. The main Clear Creek Flume and water from smaller tributaries flow through the foreground from left to right. (Both photographs by Carleton E. Watkins.)

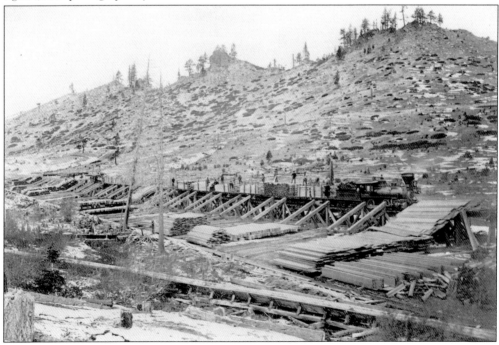

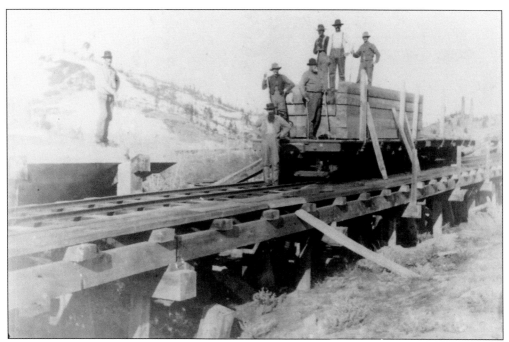

At the end of the line for the railroad and the beginning of the Clear Creek Canyon flume down to Carson City, Summit lumber crews prepare to unload 14-inch square mining timbers off Lake Tahoe Narrow Gauge Flat Car No. 36. Despite the May 1892 sunshine, there is still snow on the ground and, of course, all of the men are wearing hats. (Photograph by George D. Oliver, courtesy Nevada State Railroad Museum.)

Viewed from the Carson Valley floor, the challenge of the Summit/Clear Creek Canyon flume looks daunting. In a span of 12 miles, the flume safely transported wood products—and anything else that accidentally fell in—from an elevation of 7,146 feet down to Carson City at 4,684 feet at a speed of up to a mile a minute.

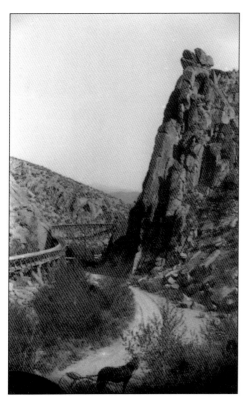

The photographer took his horse and buggy up Clear Creek Canyon road (left) for a view of the flume as it snaked through Devil's Gate on its way to Carson City. Watchmen, or "flume-tenders," had cabins along the route and used the plank walkways (below) to keep the products flowing downstream. Small feeder flumes provided additional water along the way. (Both, Nevada State Railroad Museum.)

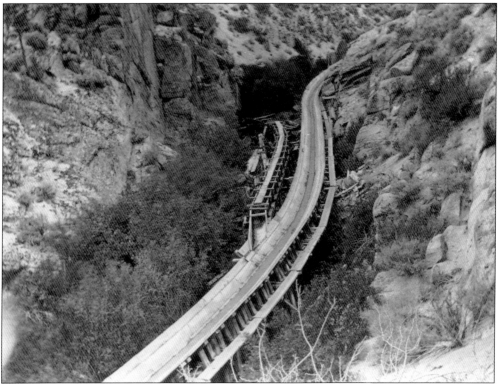

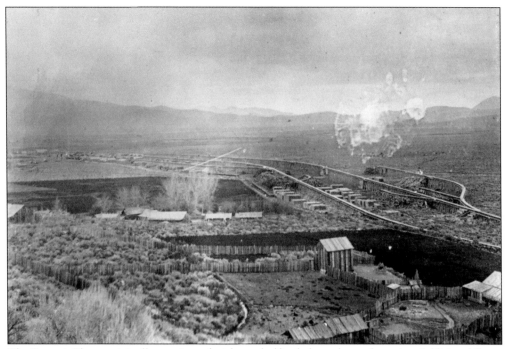

The Summit Flume originally terminated with two half-mile-long elevated arteries. Additional flume offshoots soon expanded the yard with designated cordwood, timber, and lumber areas, surrounded by several miles of V&T spur tracks. The excess water eventually joined the Carson River. The southern outskirts of Carson City are visible in the distant left. (Robert C. Dockery collection.)

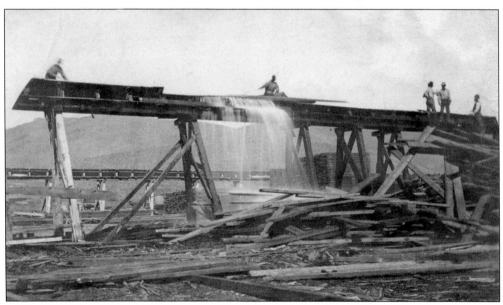

C&TL&F workers discharge lumber from the company's elevated "V" flume southwest of Carson City around 1877. The building lumber will be carefully stacked and allowed to dry before it leaves the yard. Wood fluming was seasonal and dependent on adequate water flow. (Photograph by Carleton E. Watkins.)

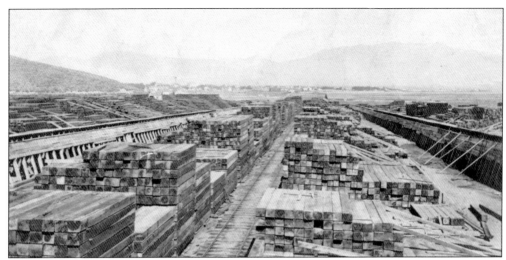

"Mountains" of expensive 14-inch square-set mining timbers were meticulously stacked on the floor of the Carson Valley. The V&T had four 4,000-foot-long standard-gauge spur tracks running between the lateral flume branches in the sprawling woodyard. (Photograph by Carleton E. Watkins.)

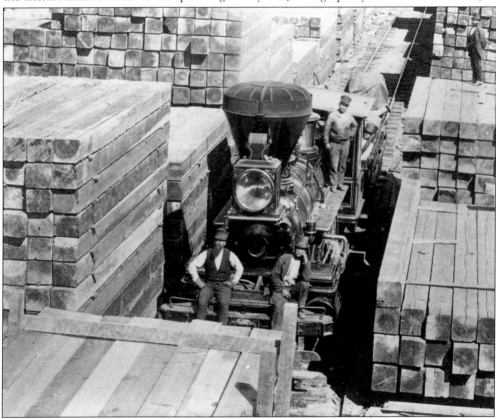

The four-man engine crew poses on board the V&T's 1870 Baldwin 2-4-0 No. 9 *I.E. James*, before coupling onto a flatcar load of planking. For three decades, the *James* was the V&T's assigned switch engine in Carson City and the primary locomotive that handled empty and loaded flatcars in the woodyard. (Photograph by Carleton E. Watkins.)

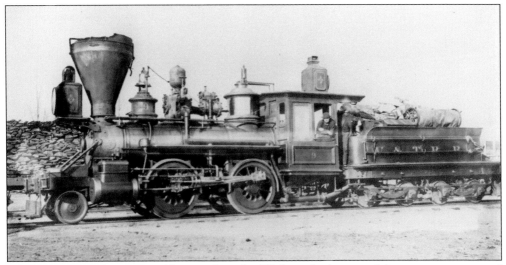

Like its sister switch engine in Virginia City, the *I.E. James* had a powerful steam-pump mounted atop its boiler for firefighting purposes. Fire was the greatest threat in a tinder-dry woodyard. The worst fire in the history of the C&TL&F occurred when 8,500 cords were consumed on the night of Friday, November 2, 1877. The origin of the fire was never determined. (Everett W. Harris collection.)

The V&T used a portable steam engine to power a belt-driven table saw that cut 48-inch-long cordwood in half so it would fit into locomotive fireboxes. The boiler was built in 1874 by the J.C. Hoadley Company of Lawrence, Massachusetts. The boiler, the engine with a single seven-by-ten-inch cylinder, and four-wheel wagon cost the V&T $654 in 1874. (California State Railroad Museum.)

In addition to fluming wood to Carson City, several large wood drives each spring sent millions of board feet down the Carson River from Alpine County, California, to Empire City and as far as Dayton, Nevada. Log dams and large chains held cordwood in the river until the desired release time. A typical cordwood run might take up to 22 days, with men stationed with hooked poles along the way to prevent logjams.

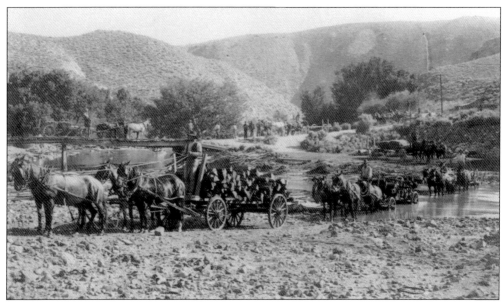

There were several large cordwood yards along the V&T at Empire City. Teams with wagons also waded into the Carson River to retrieve cordwood that had been cut and floated down from the mountains. James H. Crockwell took this 1889 photograph of wagons loading cordwood near the Brunswick Mill for hauling up to Gold Hill and Virginia City. (Harry R. Kattelmann collection.)

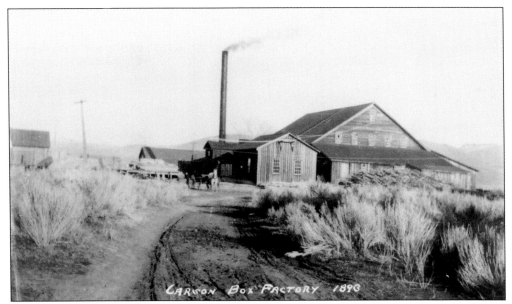

C&TL&F purchased the steam planning mill of A.H. Davis & Son and operated it as the Carson Box Factory through 1898 in Carson City. The factory was a production planing mill that specialized in smaller wood products, such as wooden roof shingles and reusable wooden fruit and packing boxes. The factory routinely filled large orders for fruit and dry goods boxes from as far away as Los Angeles and Riverside, California.

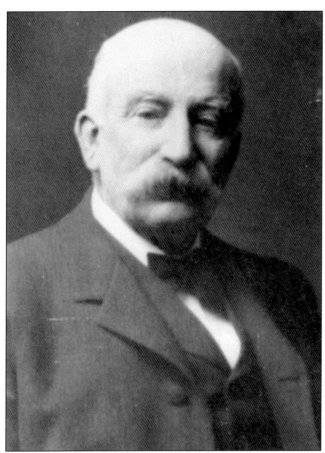

Duane LeRoy Bliss was born in Savoy, Massachusetts, in 1833, and he was in Nevada by 1860 as a miner, merchant, and banker. Bliss became president of the new C&TL&F Company in 1873. Together with his second wife, Elizabeth Tobey, the Bliss family had a home at Glenbrook. In 1879, Bliss built a palatial residence at Mountain and Robinson Streets in Carson City. Constructed of clear sugar pine and square nails, the three-story residence was the largest private home in the state when it was erected. Designed in the Victorian Italianate style, the home was the first residence in Carson City to be entirely plumbed for gas heating and lighting. The house was later occupied by Edward Boucher Yerington, secretary of the C&TL&F and the eldest son of Henry M. Yerington. The restored residence still stands. (Both, Yerington family collection.)

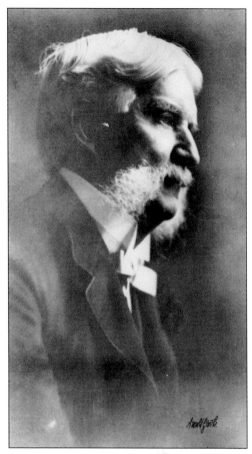

Henry Marvin Yerington sat for famed German-born portrait photographer Arnold Genthe during one of Yerington's periodic trips to San Francisco. In his 70s, the tall, "grand old man of Nevada" had stellar white hair, distinctive muttonchop whiskers, and a daily fresh carnation in his lapel. Yerington was the V&T's senior on-site official. He was also an officer or on the board of more than 40 V&T-affiliated railroad, mining, milling, lumber, fluming, water, toll road, mineral, and other land ventures throughout Nevada and eastern California. After arriving in Nevada in 1863, Yerington made Carson City his home for the next 47 years. The sprawling family house is still intact on the southwest corner of Division and Robinson Streets in Carson City. (Both, Yerington family collection.)

The general office of the C&TL&F Company was this building located in the Virginia & Truckee's Carson City yards. The structure was just east of the V&T's Carson City Passenger Depot and the office of H.M. Yerington. A dedicated telegraph line connected Carson City with D. L. Bliss at Glenbrook for special and rush orders of mining timbers and building lumber. (Photograph by Grahame H. Hardy.)

The Carson & Tahoe Lumber & Fluming Company's office was staffed by several clerks and housed decades of company records. After timber harvesting concluded in 1898, the C&TL&F was in the property management and sales business through March 1947. The office, walk-in vault, and hand-lettered vault door were still intact until they were razed in April 1963. (Photograph by Edward R. Strong.)

Five

OTHER 19TH-CENTURY TAHOE LOGGERS

Comstock production of silver and gold was at an all-time high during the bonanza years of 1875 through 1878. The Carson & Tahoe Lumber & Fluming Company was working efficiently with its complex of sawmills at Glenbrook. But there was still demand for timber products, and the C&TL&F had additional capacity. The company owned even more stands of timberlands at the south end of Lake Tahoe and it began negotiating with others to harvest their forests.

Beginning in 1875, Yerington and Bliss entered into multiyear contracts with area loggers to develop the resources, the roads, and the railroads to deliver logs lakeside where C&TL&F tugboats could tow them to Glenbrook for milling. Matthew Culbertson Gardner of Carson City received a multiyear contract to deliver 60 million board feet of lumber per year from the Tallac Woods at the southwest end of Lake Tahoe. To assist, Gardner built the only standard-gauge railroad at the lake until 1926.

In 1884, George Washington Chubbuck obtained timber rights and soon began construction of a narrow-gauge railroad at Bijou, South Lake Tahoe. Two years later, the property fell into the hands of the C&TL&F and affiliated Eldorado Wood & Flume Company, whereupon the timber was harvested and carried on the new narrow-gauge Lake Valley Railroad.

For five years, the fiercely competing "Bonanza Firm" of Mackay, Fair, Flood, and O'Brien had its own logging operation northeast of Lake Tahoe called the Pacific Wood, Lumber & Flume Company (PWL&F), which delivered timber products to the V&T station at Huffakers, south of Reno. PWL&F and its contractors employed more than 500 men. Its flume easily handled 500 cords of wood and more than 100,000 board feet of lumber per day.

Walter Scott Hobart and Samuel Hunt Marlette had their own narrow-gauge Sierra Nevada Wood & Lumber Company (SNW&L), which delivered logs to a sawmill at Incline Village, located on the northeast shore of the lake at Crystal Bay. A spectacular cable incline railroad and long flume delivered wood products to Lake View from 1879 to 1894 on the V&T. From Lake View, the wood was delivered to the Comstock and to points on the Central Pacific.

The demand for Tahoe timber was only accelerating.

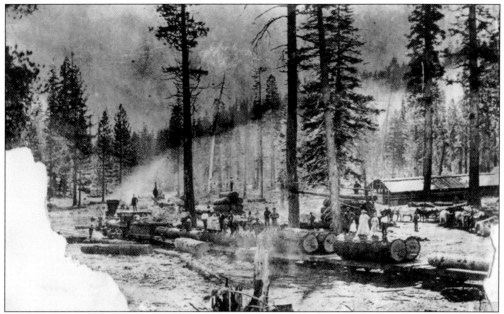

M.C. Gardner's "almost" standard-gauge railroad extended five miles into the forest at what became Camp Richardson at South Lake Tahoe. The V&T leased its old locomotive No. 2 *Ormsby* to Gardner and helped him secure 10 new 4-foot 7.75-inch-gauge flatcars, Nos. 1 to 10, from the Detroit Car Works. At Gardner's request, the V&T renamed the locomotive *Mountaineer* before he took possession in mid-1875. (Gilbert H. Kneiss collection.)

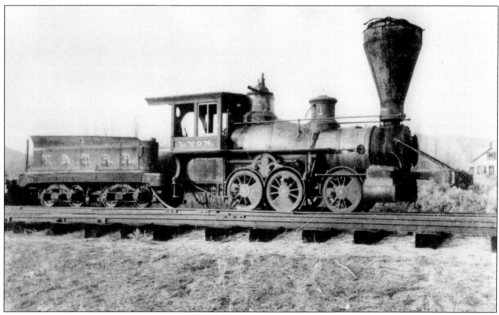

The *Ormsby* was identical to the Virginia & Truckee's Locomotive No. 1 *Lyon*, which was built in 1869 by H.J. Booth & Company's Union Iron Works in San Francisco. The 22-ton 2-6-0s had 40-inch diameter drivers and 14-by-22-inch cylinders. Gardner forfeited a $500 deposit when he failed to return the *Mountaineer* and the V&T retook possession of the locomotive at Lake Tahoe effective July 1, 1880.

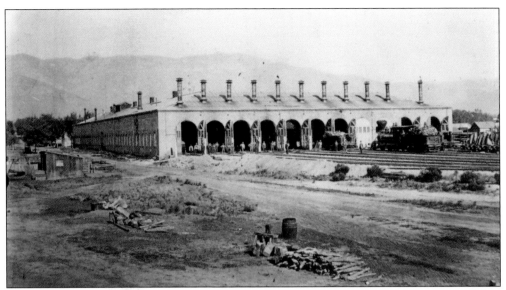

Returned to Carson City, the *Mountaineer's* boiler was removed from its frame in 1882 and then installed as the house boiler in the V&T's Carson City enginehouse and shops. The wood-fired boiler supplied steam to the engine that powered the shop's overhead, belt-driven machinery. The 34-year-old iron boiler remained in use until October 22, 1903, when it was finally shut down and replaced. (Photograph by C.E. Peterson.)

GARDNER'S RANCH

ON THIS SITE IN THE PERIOD FROM 1870 UNTIL 1918 STOOD THE ORNATE TWO-STORY HOME OF MATTHEW CULBERTSON GARDNER, RANCHER AND LUMBERMAN. THE RESIDENCE WAS HEADQUARTERS FOR GARDNER'S 300 ACRE RANCH IN MEADOWS TO THE SOUTHWARD.

HERE WAS LOCATED, 1870-1898, THE CARSON-TAHOE LUMBER AND FLUMING COMPANY'S LARGE LUMBERYARD. DURING THE 1870'S AND 1880'S GARDNER LOGGED SOUTH OF LAKE TAHOE FOR THE COMPANY AND BUILT THE ONLY STANDARD GAUGE LOGGING RAILROAD IN THE TAHOE BASIN. HE MAINTAINED HIS HOME HERE.

GARDNER DIED IN 1908. THE RESIDENCE WAS DESTROYED BY A FIRE AUGUST 20, 1918. MANY OF THE OLD TREES ON THE GROUND ONCE SHADED THE GARDNER FAMILY.

STATE HISTORICAL MARKER NO. 194

NEVADA STATE PARK SYSTEM

CARSON CITY HISTORICAL COMMISSION

M.C. Gardner returned to Carson City, his 300-acre ranch and home south of town. Gardner died in June 1908 at the age of 73 and was buried in Carson City. The two-story family house burned in August 1918. The ranch site is marked today by a stone building and a historical plaque on South Carson Street at the foot of Stewart Street in Carson City.

George W. Chubbuck was born in Massachusetts in 1828, and he moved his family overland in 1876. In 1880, he was a wood dealer out of Carson City and soon began logging with French Canadian fallers and Chinese laborers at South Lake Tahoe. A contract with the C&TL&F followed shortly thereafter. (Lake Tahoe Historical Society.)

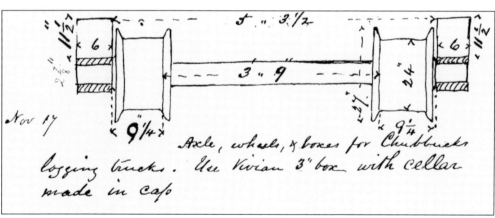

Chubbuck's next logging advancement was to develop a horse- and oxen-drawn four-and-a-half-mile-long tramway using square-timbers as rails and short flatcars built from V&T hardware. A November 17, 1885, order book from the V&T's Carson City shops contains a drawing for unusual-gauge, double-flanged wheels for Chubbuck's four-wheel log cars. Logs were rolled from the four-foot-gauge tramway cars directly into the lake. (Nevada State Railroad Museum.)

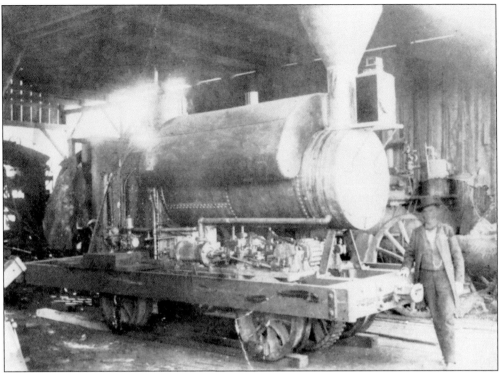

The *Old Morsby* was an unusual 0-4-0 tank engine that Chubbuck acquired in 1886 for his lumber road. The nine-ton engine could achieve eight miles per hour on an upgrade but was understandably hard on the timber rails. The engine was soon relegated to non-railroad service as a steam donkey log loader. (*Western Railroader.*)

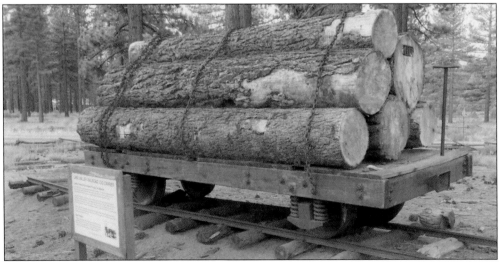

Thwarted by his innovative approach to lumber railroading, Chubbuck concluded to go with more proven technology: 35-pound steel rails spiked to three-foot gauge and a conventional steam locomotive. A representation of one of Chubbuck's four-wheel log cars on narrow-gauge 35-pound rails, set on the original right-of-way, was built by Bill Ruggiero and is on display in Bijou Park at South Lake Tahoe.

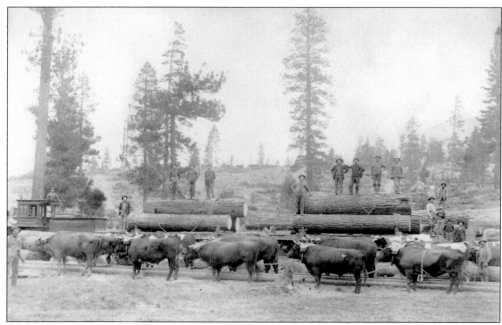

Yoked oxen straddle the logway from where sawn logs are being loaded in August 1888 aboard flatcars to be pulled by the locomotive *Santa Cruz* to the Bijou wharf. Chubbuck lined up use of the Santa Cruz & Felton three-foot-gauge 1875 H.K. Porter-built 0-6-0 *Santa Cruz* in 1886 along with the use of three ex–Carson & Colorado flatcars a year later. (Gilbert H. Kneiss collection.)

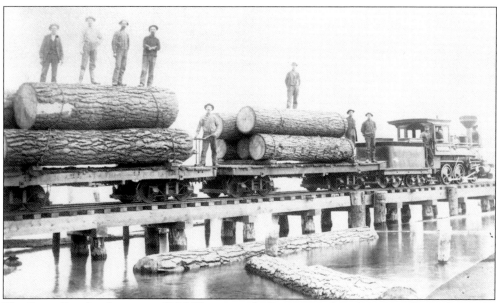

The *Santa Cruz* heads a train of LTNG cars on the Bijou pier where logs were dumped into the lake for towing to Glenbrook. Chubbuck ran into financial difficulties in 1886, and the operation was assumed by C&TL&F. A new Lake Valley Railroad was incorporated in November 1887 to operate and extend the three-foot-gauge railroad. Yerington was president and Bliss was treasurer of the new railroad. (Roy D. Graves collection.)

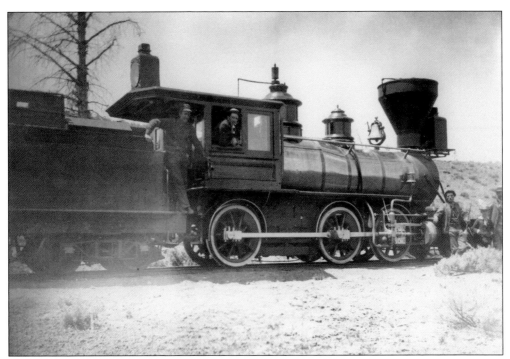

The 1877 Baldwin-built 2-6-0 locomotive No. 3 was soon barged over from Glenbrook to assist in timber operations on the new Lake Valley Railroad. Beneath the cab roof are engineer Fred Johnson and fireman James R. Vair. Brakeman Dave Fountain leans again the right-side steam chest in the early 1890s. (Photograph by George D. Oliver.)

Ten C&TL&F flatcars were also barged over from Glenbrook to Bijou for use on the new Lake Valley line. In the spring of 1893, the flatcars were being loaded with logs at a staging yard alongside Trout Creek near Meyers. The "giants of the forest" were in route to the Bijou wharf and then the sawmills at Glenbrook. (Photograph by George D. Oliver.)

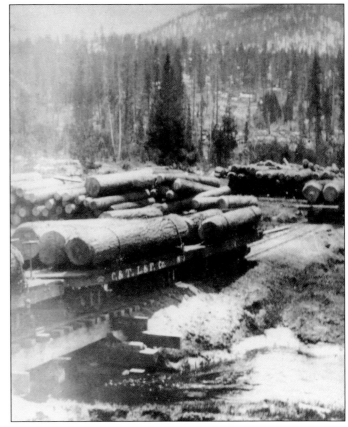

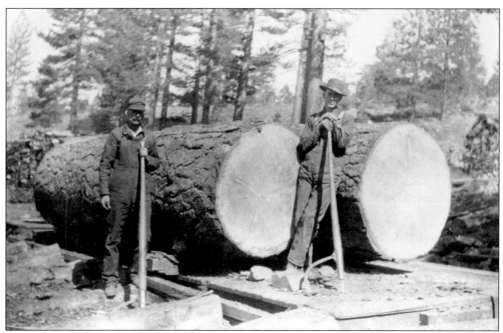

George Oliver took this image of two men manhandling a couple of four-foot-diameter old-growth trees on narrow-gauge flatcars. While usually rated for 10 tons, the wood-frame flatcars were frequently stretched to capacity by some of the first-generation monarchs of the Sierra. (Lake Tahoe Historical Society.)

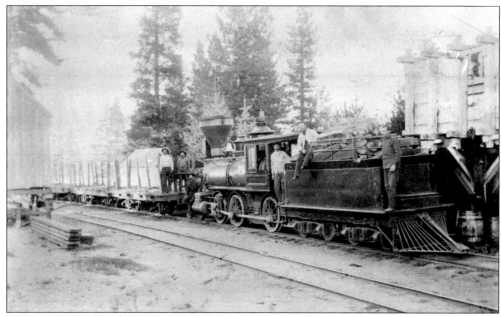

Locomotive No. 3 and train crew handle a load of empty flatcars off the shore end of the Bijou pier in the early 1890s. Behind the train are the water tank and modest shop facilities of the Lake Valley Railroad. Lacking any turning facilities on the railroad, No. 3 was fitted with a rear tender pilot for use when backing. (Photograph by George D. Oliver, courtesy Lake Tahoe Historical Society.)

The No. 3 has pushed a string of flatcars out onto the Bijou wharf to unload logs into a large boom being assembled for the sawmills at Glenbrook. The 1,800-foot-long pier permitted an entire trainload of logs to be shoved out over the lake for unloading. (David F. Myrick Collection, Nevada State Railroad Museum.)

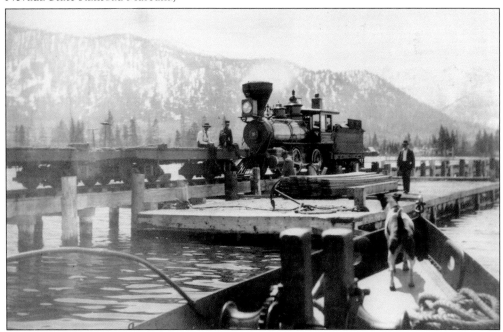

A terrier on the iron bow of the C&TL&F's *Emerald II* looks expectantly as the vessel nears 2-6-0 No. 3 and one of the company's six barges on Bijou pier in the spring of 1891. The 60-foot-long tugboat was built in 1887 by the Union Iron Works of San Francisco and worked until finally retired from the water in 1935. (Photograph by George D. Oliver.)

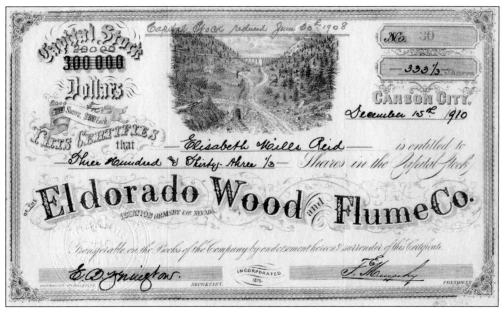

The Eldorado Wood & Flume Company (EDW&F) was another operation initially organized in 1875 by H.M. Yerington, wood dealer Capt. John W. Haynie, Alexander Jackson Ralston, and D. O. Mills to log lands at South Lake Tahoe, Hope Valley, Woodfords, and Alpine County, California. The company owned 5,496 acres of timber land at the lake and 3,560 acres in Washoe County. EDW&F worked seamlessly with C&TL&F and its logging at Lake Tahoe.

E.B. Yerington took this c. 1889 photograph of the second-growth timber in Hope Valley, located about 15 miles south of Lake Tahoe. Captain Haynie and EDW&F first secured deeds and timber leases in 1875 to log the scenic valley. With the wood gone by 1880, EDW&F began leasing the good summer grazing lands for pasture and development of large ranches. (Yerington family collection.)

LAKE TAHOE FIRE COOPERATIVE AREA

LEGEND
● Fires in 1930
— Boundaries of Tahoe
and Eldorado National Forests

The checkerboard section of land at the south end of Lake Tahoe was the location of the Lake Valley Railroad. Up until the early 1930s, the land in this section was still largely held by the C&TL&F and EDW&F companies. It constituted some of the last privately owned inholdings in the developing Eldorado National Forest.

Eldorado Wood & Flume was also involved with logging and fluming at Markleeville and nearby Woodfords in Alpine County, California, in the late 1870s. The earlier land and water rights of the Markleeville Flume Company were deeded to EDW&F in September 1875. After logging trees larger than 15 inches in diameter over a period of five years, EDW&F entered the land management business, renting and selling land over the next six decades. Edward Yerington took these photographs of the second-growth timber and local development at Woodfords in 1889. (Both, Yerington family collection.)

E.B. Yerington took this photograph of a white ranch house nestled amidst second-growth timbers in 1889 at Woodfords, Alpine County, California, on former property of the Eldorado Wood & Flume Company. (Yerington family collection.)

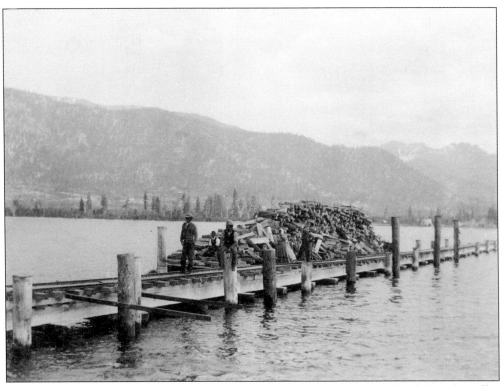

A C&TL&F cordwood barge awaits unloading alongside the Bijou pier tracks of the Lake Valley Railroad. At its peak, the Lake Valley extended 11.5 miles from Bijou south along Trout Creek. With the timber resources about exhausted, the 35-pound rails were pulled up in mid-1898, and the Lake Valley Railroad was no more.

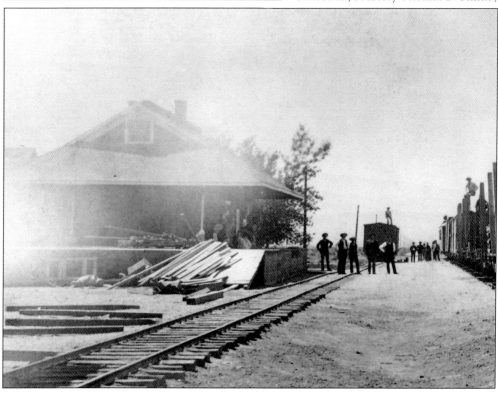

STATEMENT OF WOOD *Shipped*

At *Wabuska* Station, Month of *Feby* 1870

Date.	No. of W. B. or Shipping Bill.	From or To.	CAR NUMBERS.	Cords.

The Comstock's "Bonanza Kings" organized the Pacific Wood, Lumber & Flume Company and secured some 12,000 acres of timberland extending northward from Lake Tahoe towards the Truckee River. While lacking its own railroad, PWL&F did develop two sawmills and a 15-mile "V" flume that delivered enormous quantities of cordwood and timbers to Huffakers, where they were then shipped by the V&T.

As soon as Mackay & Fair's competing PWL&F concluded shipping timber products from the flume terminus at Huffakers, the V&T promptly removed the mile and a half of spur tracks. The railroad closed and dismantled its 20-by-40-foot combination depot and moved it in early 1881 to become the narrow-gauge Carson & Colorado Railroad's first depot here at Wabuska, Nevada. (Robert C. Dockery collection, courtesy Thomas B. Smith.)

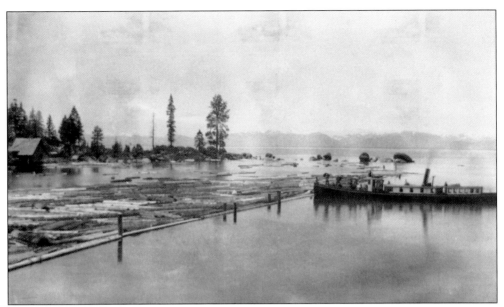

The C&TL&F steamer *Meteor* nudges against a log pond of the Sierra Nevada Wood & Lumber Company at Sand Harbor around 1889. SNW&L was incorporated in 1878, principally by W.H. Hobart and S.H. Marlette. Along the shoreline of the "pond" are a log hoisting house and the three-foot-gauge tracks of the Crystal Bay Railroad. (Yerington family collection.)

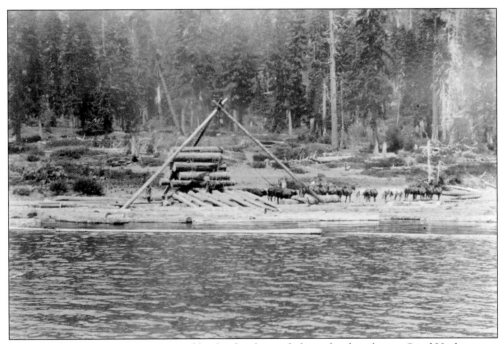

In November 1880, temporary tripod log loaders located along the shoreline at Sand Harbor were used to hoist floated logs out of Lake Tahoe and onto wagons. The wagons were then hauled by horses and oxen to the sawmill at Incline. In 1881, SNW&L began operating the Crystal Bay Railroad to ferry logs to the mill. (David F. Myrick Collection, Nevada State Railroad Museum.)

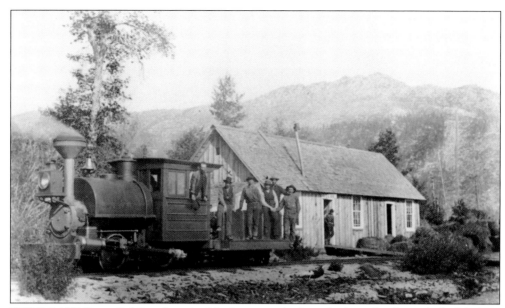

SNW&L 1881 Porter 0-4-0 tank engine No. 1 poses with a homebuilt tender alongside the Marlette & Folsom store at Incline. The pathway of the SNW&L incline is visible up behind the store. By 1889, the Crystal Bay Railroad had 11 miles of spur tracks extending from the Incline sawmill. (Photograph by R.J. Waters.)

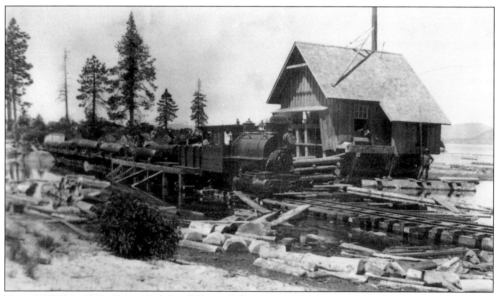

New SNW&L 1889 Porter 0-4-0 saddle tank locomotive No. 2 poses with a homebuilt tender on a spur track extending on a pier over lake waters at Sand Harbor. The small building houses a steam donkey engine that winched logs from the lake up onto the flatcars of the Crystal Bay Railroad. SNW&L operations concluded in October 1894 when the local timber supply became exhausted. (Yerington family collection.)

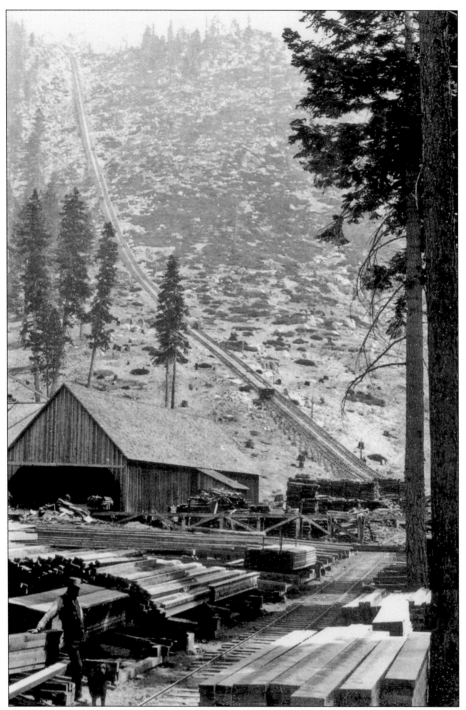

From a sawmill at Incline on Mill Creek, SNW&L forest products were hoisted up a 3,996-foot-long double-track incline and then flumed down to Lake View. A 40-horsepower steam engine powered the towering counter-balanced cable incline. SNW&L along with the C&TL&F and PWL&F were the three major Tahoe wood companies during the Comstock's period of greatest demand. (Photograph by R.J. Waters, courtesy Lake Tahoe Historical Society.)

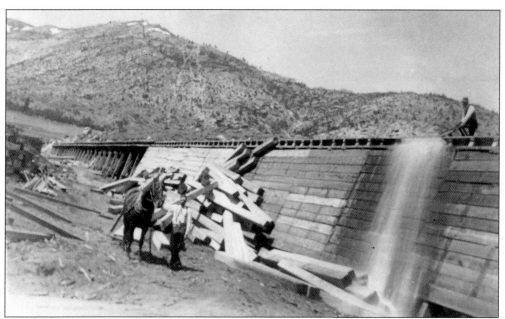

At the other end of the SNW&L flume in Washoe Valley, mining timbers were discharged from the flume and dragged down to the company's trackside lumberyard alongside spur tracks of the V&T. SNW&L employed 250 men and was fluming 400 cords per day in August 1880. (Charles Hobbs Collection, Nevada Historical Society.)

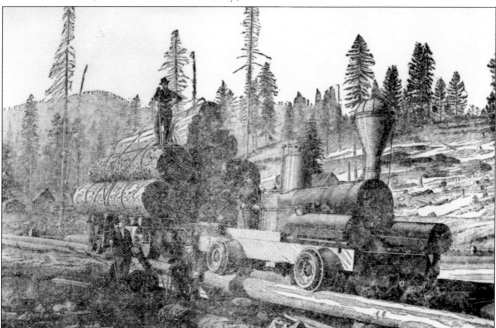

The other major 19th-century railroad logging operations in the area were centered around Truckee, California, with the 1878 Pacific Lumber & Wood Company's narrow-gauge Clinton Railroad. The tracks were moved in 1893 and became the Donner & Tahoe Railroad. George and Warren Richardson also had this unusual locomotive, which operated 1.5 miles in the late 1870s on a track made of partially buried logs. (Gilbert H. Kneiss collection.)

Six

LAKE TAHOE RAILWAY
& TRANSPORTATION

During the 1870s, 1880s, and 1890s, the fame of Lake Tahoe as a destination retreat only increased, particularly for the social elite and affluent members of society. Most of the virgin forests of Lake Tahoe had been denuded, and the Comstock showed no signs of another big bonanza. Mindful that there was a finite life to the Carson & Tahoe Lumber & Fluming, D.L. Bliss and his four sons began a retooling of the company's railroad and steamboat resources to develop Lake Tahoe as an even greater tourist attraction.

On November 19, 1895, Bliss organized the Lake Tahoe Transportation Company to own and operate the C&TL&F's *Meteor, Emerald II,* the *Tallac* (purchased from Lucky Baldwin and renamed *Nevada)*, and a new luxury steamship, *Tahoe,* to be built by the Union Iron Works of San Francisco. On December 17, 1898, the Lake Tahoe Railway & Transportation Company (LTRy&T) was incorporated by the Bliss family. The purchased railroad assets of the C&TL&F were barged across the lake from Glenbrook to Tahoe City on the northwest shore. Entire buildings, locomotives, cars, shop machinery, and track materials were towed across the lake. Tahoe City in Placer County, California, was just 14.73 miles from a connection with the overland Southern Pacific Railroad at Truckee. The new three-foot-gauge LTRy&T had a modest 2.5 percent grade. Its route followed and repeatedly crossed the Truckee River.

D.L. Bliss's son Walter designed the luxury Tahoe Tavern at the foot of the Tahoe Wharf. The tourist experience brought travelers in daily from Truckee, afforded them a first-class hotel, and scenic steamship day trips around the grandest mountain lake in North America.

Southern Pacific and LTRy&T joined forces to market the summer tourist attraction. SP leased the line in 1925 and standard-gauged the route the next year. Summer and winter operation of the so-called Lake Tahoe Route continued into 1942.

D.L. Bliss died in 1907 at the age of 74, his dream fulfilled of making Lake Tahoe a major tourist destination.

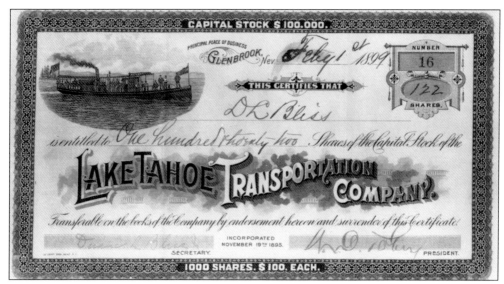

An illustration of the steamer *Meteor* uniquely identifies the stock certificate of the Lake Tahoe Transportation Company, this one issued in 1899 to D.L. Bliss. The company's place of business was still Glenbrook, Nevada. Company president Walter Danforth Tobey was Bliss's brother-in-law. Secretary Duane Bliss Jr. was Bliss's fourth and youngest son. (David F. Myrick Collection, Nevada State Railroad Museum.)

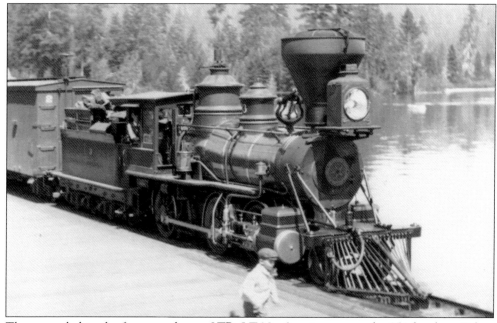

The young lad in the foreground races LTRy&T No. 3 to its stop on the 954-foot-long Tahoe Wharf after the mixed train's early morning arrival from Truckee. The former C&TL&F No. 3 has now been fitted with air brakes, although it still retains its link and pin couplers and oil-burning headlight. (Photograph by Stanley G. Palmer.)

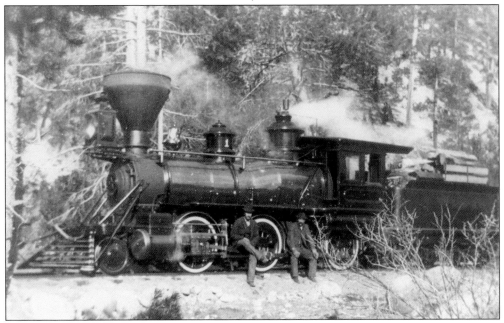

Highly polished ex-C&TL&F No. 1 pauses briefly in the morning sun at Deer Park, California, on the morning run to the new Tahoe Tavern and Wharf. It is the summer of 1901, the second full season of the LTRy&T's summer operating schedule. Locomotive engineer Frank Titus Sr. and his fireman sit between the drivers. (Richard C. Datin Jr. collection.)

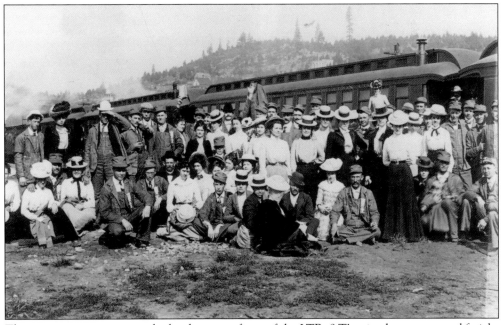

The excursionists squint in the bright sun in front of the LTRy&T's mixed passenger and freight train on June 17, 1901, at Truckee. Most of the men are wearing bib overalls, and most everyone is also wearing a hat. In the back are a few of the railway's some dozen highly varnished passenger cars, the majority of which were purchased secondhand. (David F. Myrick Collection, Nevada State Railroad Museum.)

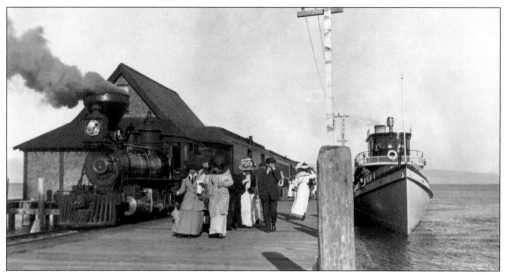

LTRy&T Locomotive No. 1 has backed its passenger train onto the Tahoe Wharf where the steamer *Tahoe* has just pulled in from its 76-mile trip around Lake Tahoe. The date is around 1908, when the traveling public still "dressed" for social events and outings. Some steamship riders have boarded the train for the return to Truckee, while others stroll the pier, heading back to the Tahoe Tavern. (Photograph by Stanley G. Palmer.)

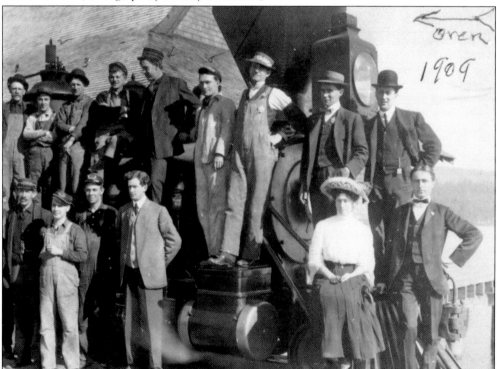

The morning train has just pulled in from Truckee in 1909. The wood-burning engine has stopped alongside the railroad's overwater warehouse. Passengers and LTRy&T crew members gather briefly around the locomotive on the Tahoe Tavern Wharf for what will be a memorable "Kodak moment." (Lake Tahoe Historical Society.)

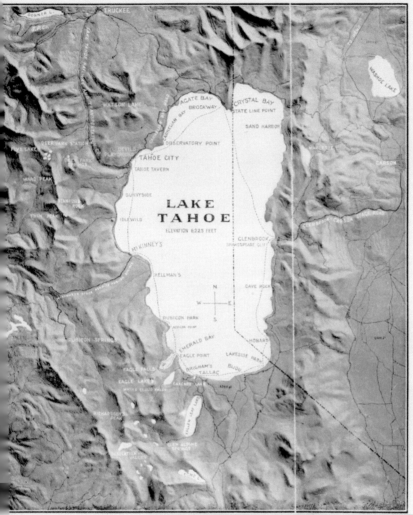

A dozen miles from the main line of the Southern Pacific, Lake Tahoe lies hidden amid the Sierra Nevada Mountains. About 23 miles long by 13 miles wide, situated at an altitude of 6,240 feet, it is the largest mountain lake in the world. Its greatest known depth is 2,000 feet, although there are some portions of the lake where the plummet has failed to find any rest and the depth is unknown. Mountains ranging from 9,000 to 10,000 feet rise from the water's edge and surround the lake on all sides, their white crests and green forests making a beautiful contrast with the blue water. One of the peculiar attractions of the lake is the marvelous clearness and beauty of its waters which reflect the wealth of peak and crest of forest, and permit the bottom to be distinctly seen several hundred yards from the shore. The lake is filled with trout, which afford excellent sport.

Lake Tahoe is reached by the Southern Pacific's Ogden Route, which connects at Truckee with the Narrow Gauge line of the Lake Tahoe Railway and Transportation Company, extending from Truckee to Tahoe City. For fifteen miles the road follows the winding of the Truckee River through a narrow valley which prepares the traveler for the beauties of the region at the end of his journey. From June 1st to September 30th the Lake Tahoe Railway trains will make two round trips daily, connecting at Truckee with Southern Pacific trains, East and West bound. From May 15th to May 31st and from October 1st to October 15th they will run one train daily, connecting with the evening train to and from San Francisco.

Enquire of Southern Pacific Conductors and Agents for actual leaving and arriving time. Also from Southern Pacific Company Bureau of Information.

"Stop at Lake Tahoe Going East or West" is the message of this 1906 brochure that was jointly issued by SP and the Bliss family's LTRy&T. The stopover trip for overland passengers "need detain them but twelve hours." In 1906, daily seasonal LTRy&T trains operated from May 15 to October 15 and with two daily trains from June 1 to September 30.

LTRy&T general agent William S. Bliss in San Francisco sent a land rental check with his letter of November 18, 1908, to Edward B. "Ed" Yerington in Carson City. Yerington was the secretary for both the Carson & Tahoe Lumber & Fluming Company and the Eldorado Wood & Flume Company. Both former lumber firms eventually rented out pasturelands around Lake Tahoe.

The display ad for the LTRy&T appears in the January 1909 issue of the *Official Guide of the Railways and Steam Navigation Lines of the United States*. In addition to passengers, the narrow-gauge railway and the steamers also carried mail and light freight for delivery to points around Lake Tahoe. (California State Railroad Museum.)

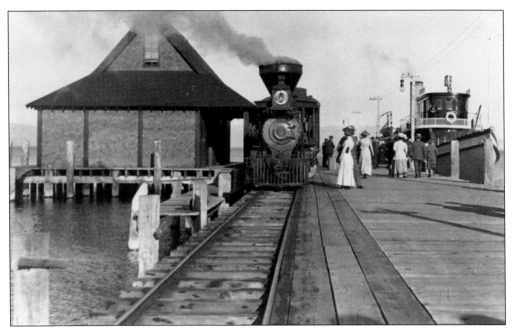

The shadows are long; it is the end of the day. The *Tahoe's* riders have enjoyed a day on the largest and most luxurious vessel on the lake in 1908. The steamer has returned to the Tavern Wharf and up to 200 passengers have transferred to the narrow-gauge train headed by locomotive No. 1 for the trip back to Truckee. (Photograph by Stanley G. Palmer.)

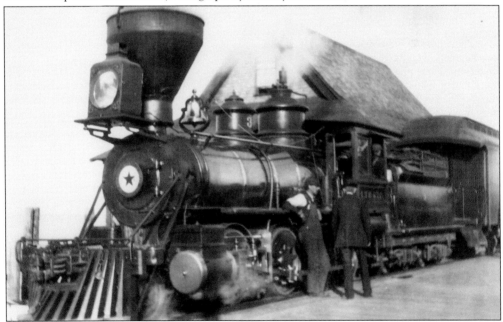

LTRy&T 2-6-0 No. 3 with its star spot-plate has backed its passenger cars onto the wharf. The fireman looks out from the cab while the engineer leans against the locomotive's running board. Both crew members await the conductor's highball to head over to Truckee for the connection with Southern Pacific. During busy summer months, the LTRy&T could run up to three trains a day.

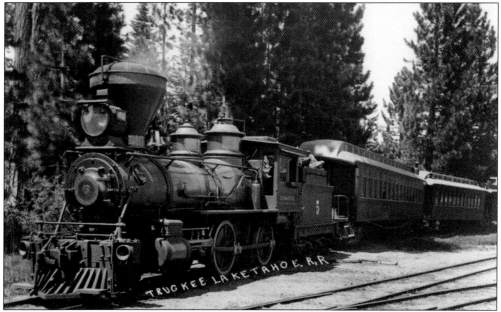

LTRy&T 4-4-0 No. 5 was built in 1877 by the Baldwin Locomotive Works and purchased secondhand for $2,500 from the South Pacific Coast Railway in late 1906. The Lake Tahoe line also leased a second SPC locomotive—oil-burning 2-8-0 No. 13—from 1915 to 1927 for use as a snowplow engine. The engine and passenger cars are near the Tahoe City enginehouse. (Roy D. Graves collection.)

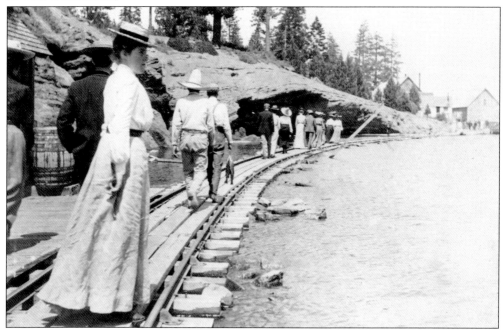

The narrow-gauge tracks extended north over a low curved trestle and the shallow lake waters along Swallow's Bank to the end of track at Tahoe City. Plank walkways between the rails allowed local residents to utilize the right-of-way for pedestrian purposes as well. At the far right are the railway's machine and car shops. (Lake Tahoe Historical Society.)

1910
LAKE TAHOE
RAILWAY & TRANSPORTATION COMPANY

PASS Mr.W.H.Kirk -------------------

Chief Engineer, V.& T.Ry.
GOOD UNTIL DECEMBER 31ST UNLESS OTHERWISE ORDERED

Walter D. Bliss.

VOID
UNLESS COUNTERSIGNED
ON BACK

PRESIDENT

The well-worn annual pass for 1910 passage over the trains and steamboats of the LTRy&T was issued to longtime V&T chief engineer William Henry Kirk of Carson City. The pass was signed by company president Walter D. Bliss and countersigned on the back by general manager Duane L. Bliss Jr.

WEST COAST MAGAZINE

LAKE TAHOE

AND RETURN

On Sale
DAILY UNTIL OCTOBER 15
Return Limit October 31, 1912.

STOP-OVERS

Allowed at Santa Barbara, Paso Robles, Castroville, Santa Cruz, San Francisco, Oakland, Merced, Sacramento and all points East of Auburn.

See "The Netherlands of America"
Take "Netherlands Route" Steamers San Francisco to Sacramento.

$25.00

From Southern California Points West of Redlands.

Anything from "Roughing It" to Luxury"
A delightful place to spend your vacation.
Thirteen miles wide.
Twenty-three miles long.
One mile high.
Half mile deep.
Beautifully illustrated resort booklet on application.

See Agents.

SOUTHERN PACIFIC

Los Angeles Offices:
600 S. Spring St. Station, 5th St. and Central Ave.

16 Please Mention West Coast Magazine When Writing to Advertisers

From 1912, a full-page Southern Pacific advertisement in *West Coast Magazine* advises vacationers of a special summer rate of only $25 from Southern California to Lake Tahoe and return. Travelers were granted stopover privileges and were told to expect "Anything from 'Roughing It' to 'Luxury.' A delightful place to spend your vacation."

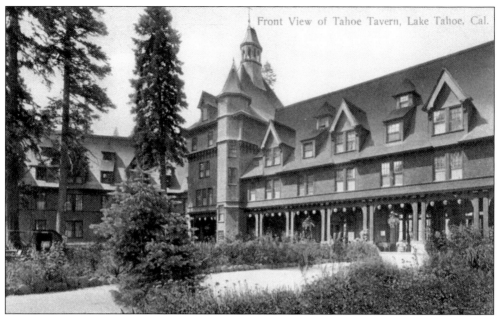

The internationally renowned Tahoe Tavern was constructed in 1901 and it opened the next year. The many-dormered hotel was constructed in a stand of virgin timber. A 60-room annex was built south of the hotel in 1906. A year later, a second floor was added with a five-lane bowling alley, a bar, novelty and barbershops, and a ballroom with stage. The six-story tower housed guest rooms and the hotel's elevator.

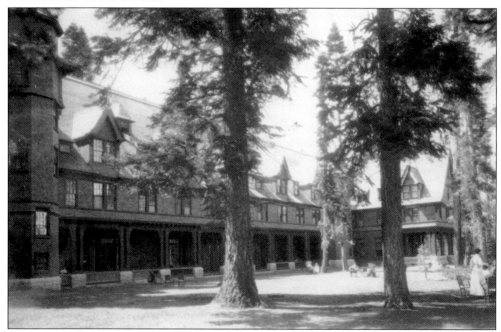

The Tavern was designed as a family resort hotel but it hosted many business meetings and conventions as well. East-side rooms offered magnificent views of Lake Tahoe. The Tavern dining room was on the extreme right end. For six decades, the Tahoe Tavern was the grand hotel on the lake.

Famed California artist Maurice Logan did a substantial body of commissioned poster art for all of the major western US railroads. These two images appear on the covers of a 1930 brochure promoting the many benefits of a visit to Lake Tahoe and the Tahoe Tavern in any season.

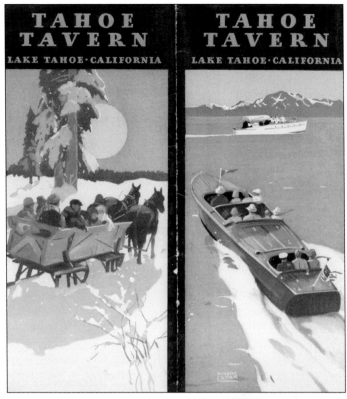

Travel to and from the Tavern was a bit more challenging in the winter, but the hostelry was able to promote being a virtually year-round vacation resort. After six decades, the famed hotel suffered a disastrous fire and was subsequently demolished. Everything from windows and doors to bathtubs and the lumber were sold off.

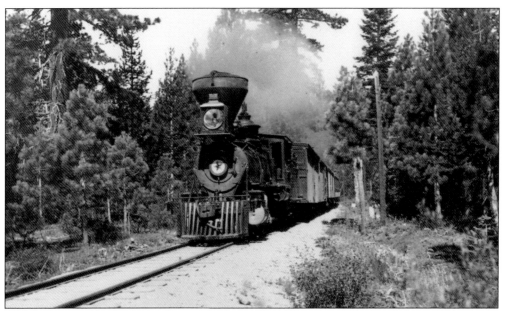

The No. 3-spot trundles along between Truckee and Tahoe City with a mixed freight and passenger train around 1910. At the time, the passenger fare was only 10¢ a mile or $1.50 for the 15-mile trip. The seasonal train left Truckee every morning and returned in the late afternoon, with extra passenger and log trains as needed. (Roy D. Graves collection.)

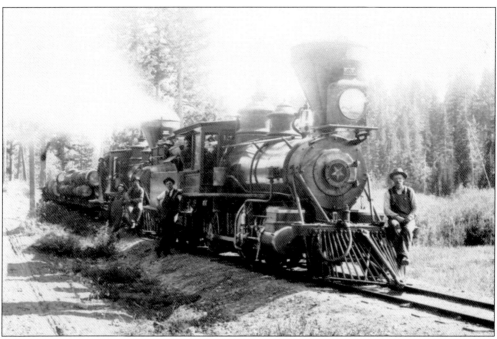

On rare occasions, the two moguls would double-head log trains in the early 20th century for the Truckee Lumber Company. In return for a much-needed right-of-way, LTRy&T gave the lumber company special freight rates on moving logs from its cutting areas by the lake to the Truckee sawmill. Like the railway, logging usually closed down each winter. (Lake Tahoe Historical Society.)

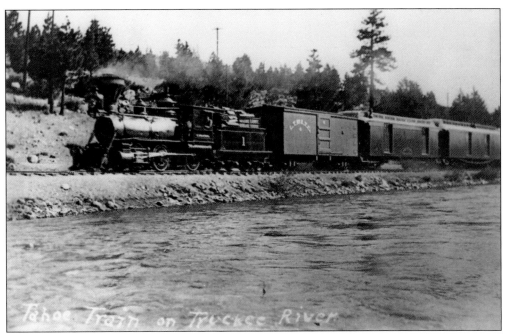

The narrow gauge followed the scenic Truckee River for most of its route, crossing the river several times on low bridges. LTRy&T employee timetables called for a leisurely 50 to 60 minutes for the 15-mile run between Truckee and Tahoe City. Always a wood-burner, locomotive No. 1 has a mixed train in tow. (Roy D. Graves collection.)

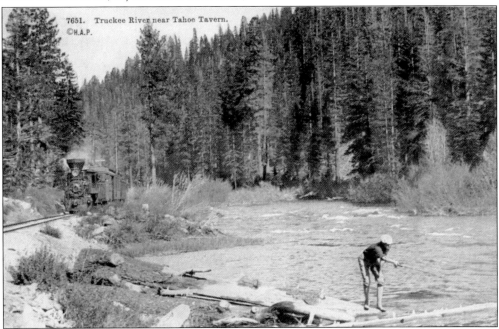

A fisherman tries his luck at catching trout in the Truckee River near Tahoe Tavern, seemingly oblivious to the impending rumble of the approaching Lake Tahoe train. The card was postmarked at McKinney's, California, in August 1911, "on the line of the Overland Limited and Lake Tahoe Steamers."

Open-air observation car No. 4 was built in 1901 by J.S. Hammond & Company of San Francisco. No. 4 was the LTRy&T's first and only passenger car to be purchased new. The 40-foot-long wooden car body was affectionately nicknamed "the Rattler" due to the noise it made as the popular rear car on passenger trains. It was photographed here as part of a 1908 Berkeley Elks Club excursion. When the conversion was made to standard gauge in 1926, No. 4's car body—minus its trucks—was sold and set on the ground at Tahoe City for the next 30 years as the Pioneer Pullman Diner. Now restored, the car is at the Colorado Railroad Museum in Golden. (Above, Louis L. Stein Jr. Collection, Nevada State Railroad Museum.)

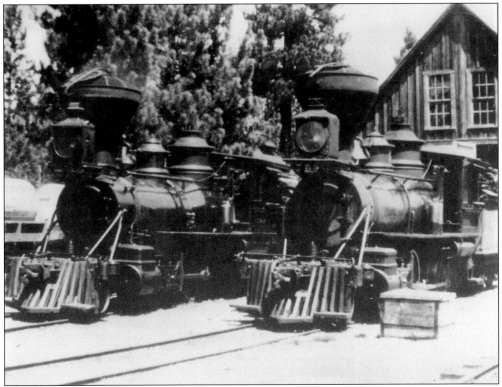

Half of the LTRy&T Company's locomotive roster—2-6-0s Nos. 1 and 3—pose outside the two-track enginehouse at Tahoe City. The line's remaining two narrow-gauge engines were also odd-numbered: 4-4-0 No. 5 and 2-8-0 No. 13. The far stub track curved around the enginehouse and held an entire train, while the track in the foreground extended north to the railway's shops. (Grahame H. Hardy collection.)

Several of the narrow gauge's flatcars were used at Tahoe City along with locomotive No. 1 to pull boats out of the lake during winter periods. The majority of the line's flatcars were built from 1875 to 1877 by the Detroit Car Works and were purchased in 1898 from the C&TL&F. (Bert H. Ward collection, courtesy Daniel D. Webster.)

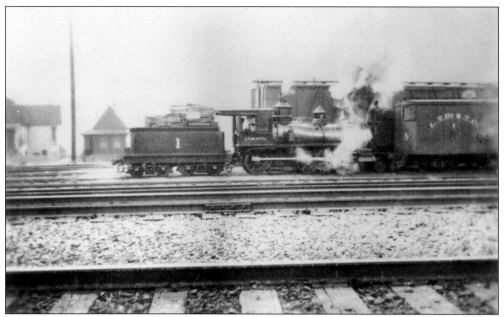

The profusion of steam indicates that No. 1 is involved in some early morning switching of LTRy&T Boxcar No. 1 at Truckee about 1921. The little steam locomotive and its 28-foot-long boxcar are dwarfed by the large boxcar immediately on the track behind. The contents of one loaded standard-gauge boxcar easily filled two narrow-gauge cars. (Grahame H. Hardy collection.)

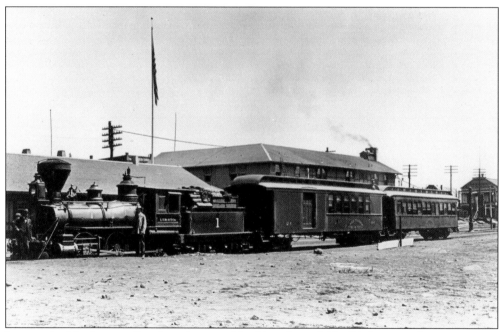

Locomotive No. 1, secondhand combination No. 24, and coach No. 76 glisten in the morning sun at the SP depot in Truckee. The passenger train is awaiting arrival of the connecting eastbound SP train from San Francisco. With an all passenger consist, there were no freight car loads for Tahoe City on this morning. (Nevada State Railroad Museum.)

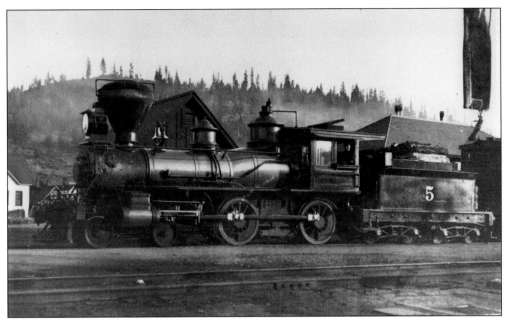

"American-type" 4-4-0 No. 5 waits its turn at the Truckee depot with the assigned morning mixed freight and passenger train in 1908. The former South Pacific Coast No. 5 was on the LTRy&T from 1906 until it was scrapped in 1926. The canvas covered spout at right dangles from the SP's water column. (Photograph by Stanley G. Palmer.)

As advised by this 1922 SP circular, freight service was usually curtailed on the LTRy&T during winter months. Stages and sleighs helped take over the mail runs when severe weather annulled the narrow-gauge train.

SOUTHERN PACIFIC COMPANY
(PACIFIC SYSTEM)
Freight Traffic Department

ADVICE No. 50
—TO—
G. F. D. Circular No. 272-D

SAN FRANCISCO, CAL., MARCH 1, 1922

LAKE TAHOE RAILWAY AND TRANSPORTATION CO.

TO AGENTS:

The Lake Tahoe Railway and Transportation Company in their Circular No. 143 of November 14, 1921, advise as follows:

"This is to advise that all freight train service between Truckee and Tahoe, Cal., will be discontinued for the winter months after November 19, 1921.

Please be governed accordingly.

G. W. LUCE,
Freight Traffic Manager.

The distinctive "Truckee & LK. Tahoe R.P.O." cancellation is evidence that this postcard was cancelled aboard the operating US Railway Post Office Car running between Truckee and Tahoe City. The mail route was active from 1900 through 1942—from 1900 to 1925 by the LTRy&T and 1926 to 1942 by SP. The Tahoe steamboats lost their mail contract in 1934.

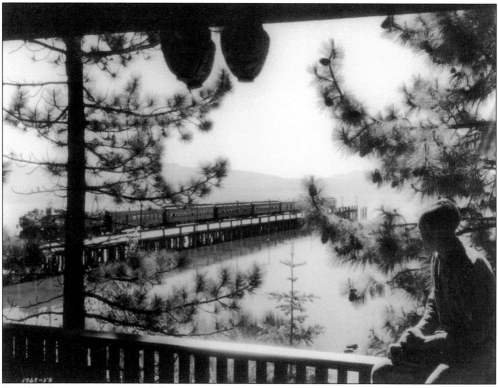

Faced with increasing automobile competition, the narrow gauge was leased to Southern Pacific for $1 per year starting in 1925, provided SP would convert the Truckee–Tahoe City line to standard gauge. The conversion was completed on May 1, 1926, and SP began running overnight Pullman service from Oakland. This SP publicity photograph was taken during 1934. The service concluded in 1942. (David F. Myrick Collection, Nevada State Railroad Museum.)

Seven

STEAMING AROUND THE LAKE

For decades, steamboats were the only effective mode of travel on Lake Tahoe. The Bliss family's Lake Tahoe Railway & Transportation Company had three intertwined components in its development of Lake Tahoe as a summer vacation destination: the narrow-gauge Truckee–Tahoe City railway, the Tahoe Tavern resort and casino, and steamboats to ply the lake's waters.

The pride of the fleet was the SS *Tahoe*, a 169-foot-long vessel that operated from 1896 through 1934 as the undisputed "Queen of the Lake." While a celebrated passenger steamer, the *Tahoe* was also an important cargo vessel that hauled US mail, baggage, freight, and small parcels for the resorts and cabins of prominent families scattered around the lake.

The morning 8:00 a.m. train from Truckee discharged passengers at Tahoe Tavern and then proceeded out onto the Tavern Wharf to make 9:00 a.m. connections with often two boats: one circled the lake clockwise while the other, the *Tahoe*, circled counterclockwise. The boasts passed each other near Al Tahoe and returned to the Tavern Pier at 5:00 p.m. from May through October.

The *Tahoe* made brief stops at the major resort areas with useable piers, including McKinney's, Rubicon Park, Emerald Bay, Tallac, Bijou, Lakeside, Glenbrook, and Brockway. Boat passengers had stopover privileges for sightseeing trips and picnics. The vast lake was also home to private launches, sailboats, and small fishing boats.

For 25 years, the LTRy&T's steamboats had a virtual monopoly on lake travel. The year 1924 marked the first summer season where the rise of personal automobiles, trucks, and buses offered serious competition to the Bliss family's packaged vacation. By 1925, roadways completely encircled the 75-mile circumference of Lake Tahoe. In 1934, the steamers lost the mail contract and the boats did not run during 1935. After decades of exclusivity, the legendary vessels succumbed to the increasing drone of modern, rubber-tired vehicles. Revered tugboats and passenger steamers like the *Emerald*, *Truckee*, *Niagara*, *Meteor*, *Tod Goodwin*, *Tallac/Nevada*, and SS *Tahoe* were becoming but memories.

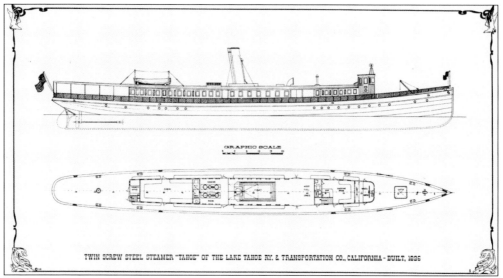

TWIN SCREW STEEL STEAMER "TAHOE" OF THE LAKE TAHOE RY. & TRANSPORTATION CO., CALIFORNIA - BUILT, 1896

The Lake Tahoe Railway & Transportation Company's steamship *Tahoe* was ceremoniously launched from Glenbrook on June 24, 1896 (below). Hailed as the most luxurious passenger carrier on the lake, the steel-hulled SS *Tahoe* was 169 feet long and held 200 passengers. A single locomotive-type boiler, twin steam engines, and two manganese-bronze propellers all contributed to its maximum speed of 18.5 knots per hour. The vessel was built by the Union Iron Works of San Francisco and hauled in pieces by Southern Pacific from Oakland to Reno, by the V&T to Carson City, and then by wagons and mules to Glenbrook. In 38 years of operation, the steamship had only four captains: Ernest John Pomin, Edward Hunkin, Henry Rose, and, finally, George Mawdsley. (Above, ink on linen drawing by Frederic J. Shaw, courtesy California State Railroad Museum; below, David F. Myrick Collection, Nevada State Railroad Museum.)

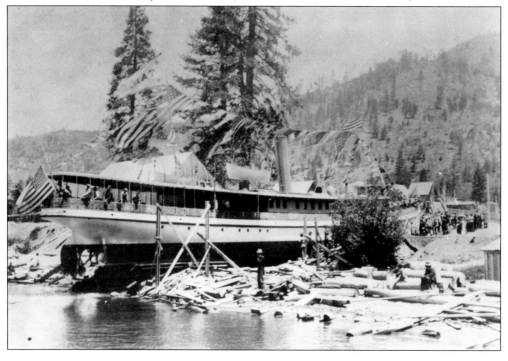

Pictured in 1902, the SS *Tahoe* was awash from stem to stern in contrasting high-gloss white paint, rich mahogany, and highly polished brass fittings. The hull was divided into eight watertight compartments, which made the ship virtually impossible to sink. The 100-foot deckhouse had a ladies' cabin, a gentlemen's smoking lounge and bar, and a dining room for 30 down below. It was the epitome of luxurious travel, gliding through the waters of Lake Tahoe with the seemingly greatest gentleness and ease. A single combined LTRy&T ticket could deliver a passenger from Truckee to Tahoe Tavern Wharf by rail and then on by steamship to any of the ports served on the lake. It was a grand and seamless way to travel. (Both, David F. Myrick Collection, Nevada State Railroad Museum.)

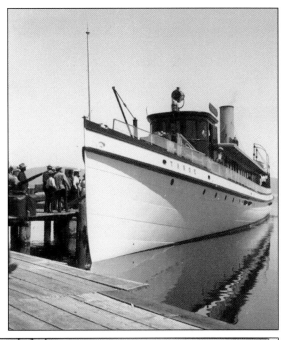

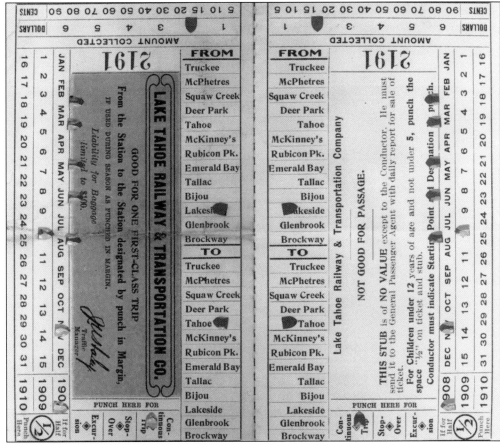

Illustrated travel brochures jointly issued by SP and the LTRy&T like this one in 1911 promote the many benefits of a summer vacation trip to the lake. The brochure reads, "It is difficult to describe the wonderful charm and grandeur of Lake Tahoe."

LTRy&T rail service was inaugurated in May 1900. This rare pass was issued by the steamship company for its 1899 season. Signed by C.T. Bliss, it features a likeness of the company's 1876 *Meteor*, as repurposed from log towing to passenger and mail service. The assets of the Lake Tahoe Transportation Company were sold in April 1899 for $100,000 to the LTRy&T Company. (Ron Lerch collection.)

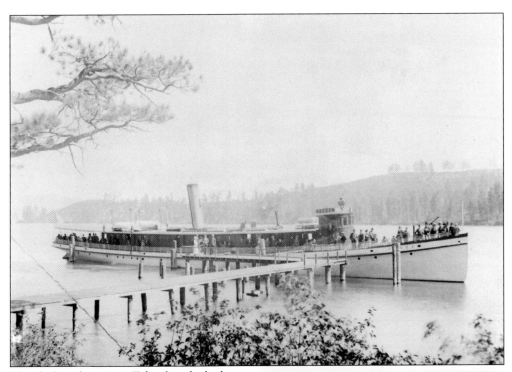

The sleek and majestic *Tahoe* has docked in Emerald Bay. The steamboat's six-man crew then consisted of a purser, steward, engineer, fireman, and two deckhands, all under the direction of Capt. Ernest J. Pomin. The photograph is attributed to Russell Cowles Graves, who operated a seasonal Emerald Bay resort from around 1907 to 1913. (David F. Myrick Collection, Nevada State Railroad Museum.)

The publicity photograph shows Miss Tahoe posing lakeside in front of Southern Pacific's standard-gauge heavyweight passenger train. SP worked hard not to miss publicity opportunities to promote the recreational and medicinal health benefits of a vacation trip to scenic Lake Tahoe—via SP, of course.

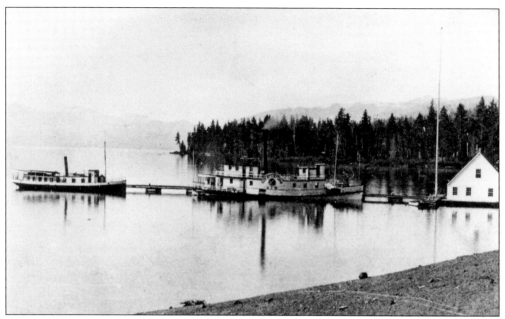

The first tugboat *Emerald* and the *Governor Stanford* were tied up at the Custom House Wharf at Tahoe City in the spring of 1878. The luxurious doubled-decked *Stanford* was launched in December 1872 to replace the 1864 *Governor Blasdel*; both steamboats were twin side paddle wheelers. The 92-foot *Stanford* cost $15,000 and had a crew of six. The vessel's boiler was condemned in 1883. (Gilbert H. Kneiss collection.)

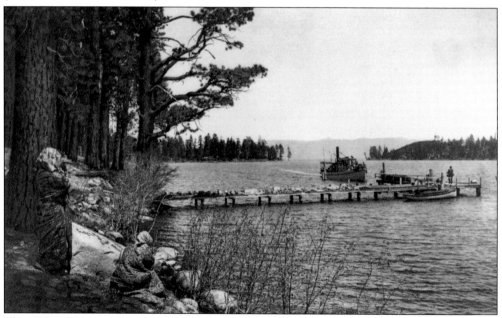

The LTRy&T's steamboat *Nevada*—formerly the *Tallac*—eases towards the dock in Emerald Bay. Both the boat and the wharf are heavily laden. Finished in teak, ash, black walnut, and cherry, the *Nevada* was a luxury excursion boat. For 35 years, it was a relief boat for the *Tahoe* during the summer months and a weekly contract mail carrier during the winter. (Society of California Pioneers.)

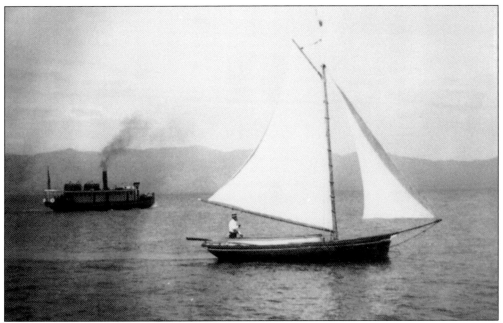

The name "Sailor Jack" was synonymous with a crusty seafaring Britisher, late of Her Majesty's Royal Navy, and something of a Lake Tahoe legend. Behind the second "Sailor Jack," Walter "Red" Comryn, and his sailboat is the 100-foot-long *Tod Goodman*. Launched in 1883 to replace the *Governor Stanford*, the wooden *Goodman* was beached in 1896 upon the arrival of the SS *Tahoe*. (Yerington family collection.)

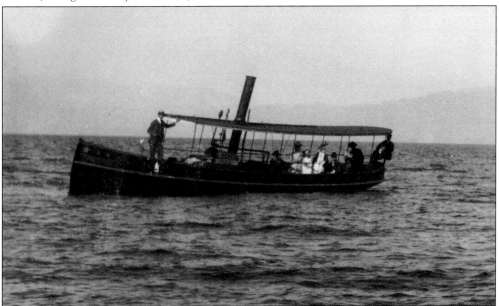

Built in 1887 by William Pomin of Tahoe City, the 40-foot *Mamie* was one of the popular small steamboats on the lake. Constructed for passengers, mail, and freight service, it was superseded by the 60-foot *Tallac* in 1890. It was then relegated to tourist sightseeing excursions, fishing trips, and moonlight cruises for up to a dozen guests of the Tallac Hotel. (Photograph by Pillsbury & Hillen.)

Near Fallen Leaf Lake and in the shadow of 9,785-foot Mount Tallac was Elias Jackson "Lucky" Baldwin's fabled Tallac House. The resort was built in 1875 by Ephraim "Yank" Clement and purchased by Baldwin during foreclosure in 1880. The white, 40-room hotel appealed to the genteel and was the upscale place to go in the 1880s and 1890s (as seen above). The 2,000-acre grounds abounded with old-growth trees, white cottages, tents, picnic grounds, a promenade, and private pier. Rowboats and fishing boats were secured around the old Tallac wharf (below), pictured around 1889. (Both, Yerington family collection.)

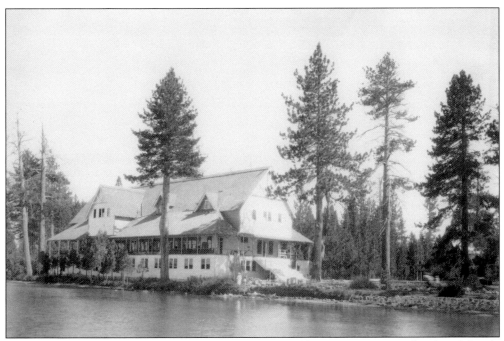

Baldwin built a new luxury Tallac Hotel in 1899 followed by an imposing 176-foot-long lakeside casino just east of the new Tallac pier. Gambling was not outlawed in California until 1911 and the three-story white casino (above) featured blackjack, roulette, dice, a theatrical stage, and a profusion of French mirrors. Advertised as "the marvel of the century," the new facilities were equipped with electric lights, a steam heating plant, extensive gardens, and fountains. The casino and hotel were billed, respectively, as "the Greatest Casino in America" and "the Summer Resort of the World." Rates were commensurate with the high quality. A women and two children (below) stroll the half mile of white sand beach to the west of the Tallac pier and the overwater boathouse and saloon.

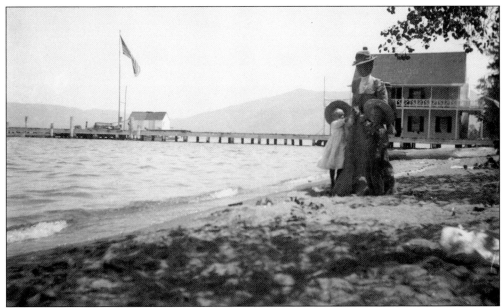

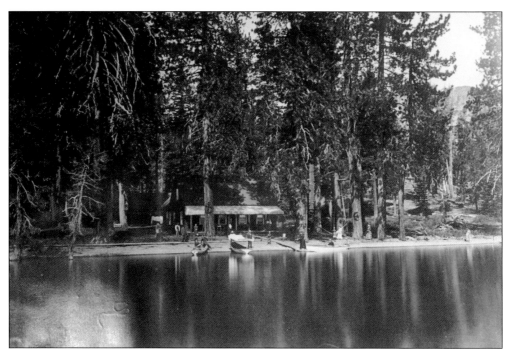

The Idlewild on Tahoe's west shore was the summer home of Margaret Eleanor Rhodes Crocker and her daughter Aimée Isabella Crocker. Margaret was the widow of California Supreme Court justice Edwin Bryant Crocker, the brother of Charles Crocker, and legal counsel to the Central Pacific Railroad in Sacramento. For decades, the Crockers were head of the local high society that flourished during summer months at the lake. Their sumptuous Idlewild home was set among 200-year-old yellow and sugar pine trees and had a stylish red-and-white-striped canvas porch awning, hammocks, cabins, tents, and a pier around 1889. The home was sold in 1905 to the Frederick C. Kohl family. In 1912, Idlewild became Tahoe Pines. (Both, Yerington family collection.)

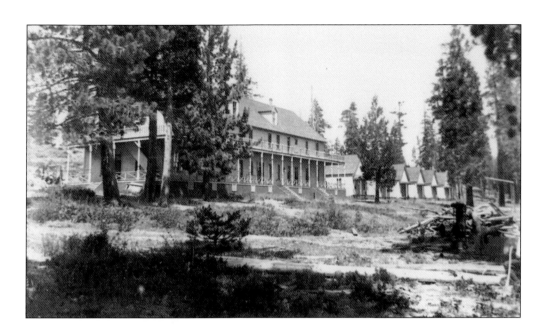

In 1889, the Bellevue Hotel was only a year old when amateur photographer Edward B. Yerington reportedly took these two images. Located at Sugar Pine Point on the west shore of the lake, the 34-by-120-foot, two-and-a-half-story structure and five single-room white cottages were built by Capt. William W. "Billy" Lapham and David Kaiser of Carson City. Bellevue was advertised as "the best family resort on the lake." Near the end of the Bellevue pier was the two-story clubhouse with a fireplace, eight second-floor employee rooms, a post office, and a saloon. Everything except the clubhouse burned to the ground in August 1893 while reportedly owned by Wells, Fargo & Company. The clubhouse was then purchased by Ephraim "Yank" Clement and barged across the lake down to Cascade House. (Both, Yerington family collection.)

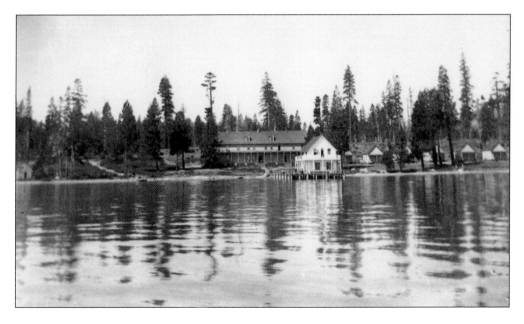

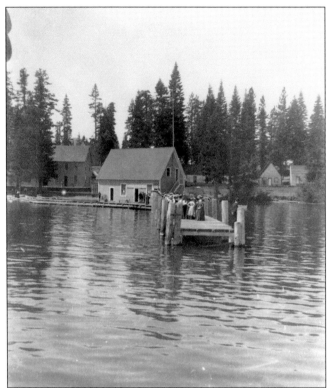

Harry Kattelmann's father took this snapshot from the SS *Tahoe* as it maneuvered around 1906 near McKinney's wharf on Tahoe's west shore. A bevy of appropriately festooned passengers occupy the short wharf while gentlemen peer out from the resort's boathouse and saloon. Behind the overwater clubhouse is the old Glen Brook House (Hotel), moved across the lake in 1897 on a cordwood barge. (Harry R. Kattelmann collection.)

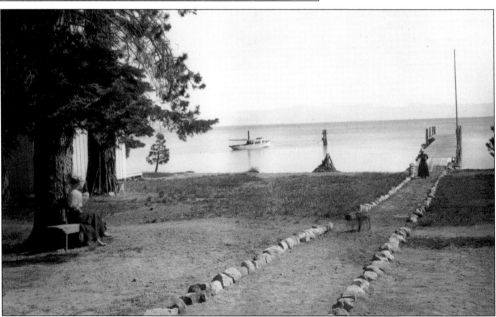

The next resort after McKinney's (later Chambers' Lodge) was Moana Villa, which advertised "just a wholesome, family style resort." The rock-bordered path leads to the Moana's long steamer pier. The 38-foot-long steam launch *Hattie Belle* is in its home port. Built in San Francisco in 1890, the wood-hulled vessel accommodated 15 passengers for excursion cruises and fishing trips. (David F. Myrick Collection, Nevada State Railroad Museum.)

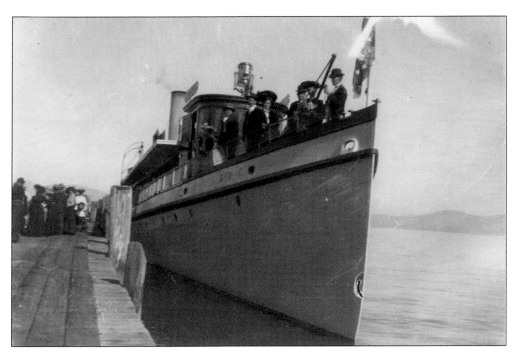

The *Tahoe* was an impressive sight around 1906 at its home port on the Tahoe Tavern Wharf. The steamer's deep-throated whistle was a staple of Lake Tahoe summers and the punctuality of its on-time arrivals and departures was legendary. The onboard guests (above) occupy bow space that was often filled to capacity with mail sacks, steamer trunks, and small freight. A 4,000-candlepower searchlight was mounted atop the pilothouse for night operation. In the scene below, the morning LTRy&T train is in from Truckee, and the wharf is teaming with appropriately dressed riders, their valises, and other hand luggage. The LTRy&T's two-story office is at the foot of the wharf. The railway's overwater freight house is at right. (Both, Harry R. Kattelmann collection.)

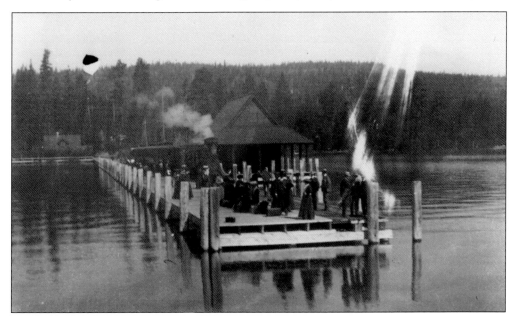

The old overwater wharf store was repositioned and reopened in May 1907 as the Glenbrook Inn, a little simpler and less pretentious than the Tahoe Tavern across the lake. Flanking the inn around 1910 are the relocated Jellerson Hotel on the left and the renovated Lake Shore House on the right. Surrounding stumps and second-growth trees are reminders of the Carson & Tahoe Lumber & Fluming Company's 25 years of heavy logging and the some 750 million board feet and 500,000 cords of wood that it extracted from the Tahoe basin. At left is a 1928 sunset over Glenbrook Pier. (Above, photograph by Putnam & Valentine, courtesy David F. Myrick Collection, Nevada State Railroad Museum.)

61. Q. Glenbrook Sunset

Eight

20th-Century Tahoe Loggers

Logging the Lake Tahoe Basin progressed rapidly from wooden-wheeled log wagons drawn by draft animals to nearly three decades of standard- and narrow-gauge railroads with steam locomotives hauling logs lakeside or to sawmills and then sawn products to connecting flumes or directly to market. The year 1898 marked the last cutting and fluming season for the Carson & Tahoe Lumber & Fluming Company. The next year saw the lowest tonnage and gross production on the Comstock Lode in its first 40 years. Paying Comstock ore and Lake Tahoe's virgin pine forests had all virtually disappeared.

Still, there was a demand for building lumber and cordwood for fuel. Wood prices advanced and by 1903 local railroads like the Virginia & Truckee were buying cordwood anywhere they could find it within 100 miles of Carson City. The technology of a flanged wheel on a steel rail would help tap still-new stands of timber in further reaches of the Lake Tahoe–Truckee River Basins. There were three major logging operators.

The Sierra Nevada Wood & Lumber Company (SNW&L) closed its spectacular Incline to Lake View operation at the end of the 1894 season and reemerged with standard- and narrow-gauge lumber lines extending from Truckee northward. SNW&L was the largest operator in the basin. Operations continued through 1937.

Located 10 miles north of Lake Tahoe, Boca on the Southern Pacific was the southern terminus for the Boca & Loyalton Railroad (B&L), which stretched 26 miles north to reach sawmills and box factories at Loyalton. The B&L eventually made an even farther-north connection with the new Western Pacific Railroad in 1908 through Portola. The B&L was active from 1900 to 1916.

Oliver Lonkey operated sawmills and lumberyards at Grass Valley, above Franktown, in Virginia City, Truckee, and beginning in 1888 at Verdi, Nevada, 18 miles north of Lake Tahoe. Starting in 1900, his Verdi Lumber Company had more than 30 miles of standard-gauge rail lines extending into the nearby woods through 1926.

Renewable forest timbers were still very much in demand.

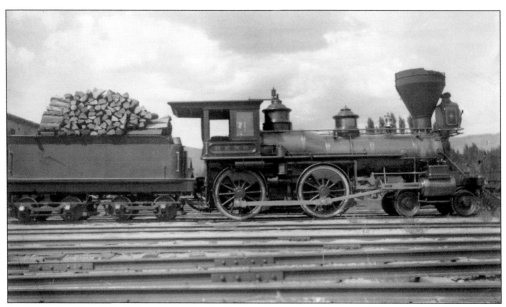

In 1904, all eight of the Virginia & Truckee's in-service engines were still burning cordwood. The wood fuel was coming in from Truckee, California. The cordwood was costing the V&T fully $5,300 per month and quantities were scarce. In 1907, V&T locomotives burned the wood from old railroad trestles from the Carson River mills. Old V&T trestles in Virginia City were then donated to help the local citizenry cook food and keep warm.

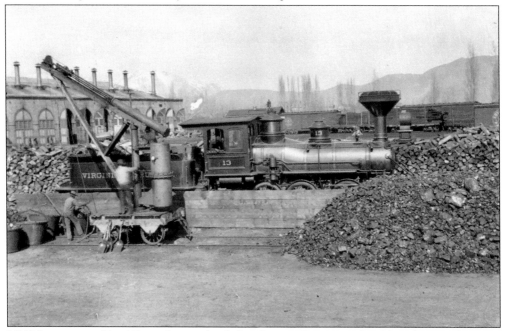

V&T Locomotive No. 13's tender was loaded at Carson City around 1908 with a combination of pine slabs and soft coal. Coal was thought to be the next economical fuel, but the supply was intermittent and expensive. By 1910, the V&T was the only Nevada short line still burning wood. In July 1911, the *Tahoe* was the last V&T engine converted from cordwood to burning fuel oil. (Photograph by Stanley G. Palmer.)

E.J. McCUTCHEN, PRESIDENT
G.D. OLIVER, MANAGER

MANUFACTURERS OF
FRUIT AND PACKING
BOXES

Doors.
Windows,
Lath. Pickets. Shingles.
Ceiling and
Flooring

RUSTIC AND SIDING.
MOULDINGS, ETC.

GENERAL MILL WORK
A SPECIALTY.

STENOGRAPHIC ERRORS SUBJECT TO CORRECTION.
QUOTATIONS SUBJECT TO PRIOR SALE.

SIERRA NEVADA WOOD & LUMBER CO.

WHOLESALE MANUFACTURERS & SHIPPERS OF

CALIFORNIA PINE AND FIR **LUMBER**

YARDS AT RENO, CARSON,
MINDEN AND LOVELOCK, NEVADA.
MAIN OFFICE, YARDS AND MILLS
AT HOBART MILLS, CALIFORNIA.

USE AMERICAN LUMBERMAN
TELEGRAPH CODE.

HOBART MILLS, NEVADA COUNTY, CAL. April, 20, 1916

Hobart and Marlette's Sierra Nevada Wood & Lumber Company was repurposed in California in 1896 with a standard-gauge line initially running from the Southern Pacific at Truckee and then north 6.4 miles to Hobart Mills, formerly Overton, in Nevada County, California. Narrow-gauge log feeder lines extended north from Hobart Mills into the nearby forests.

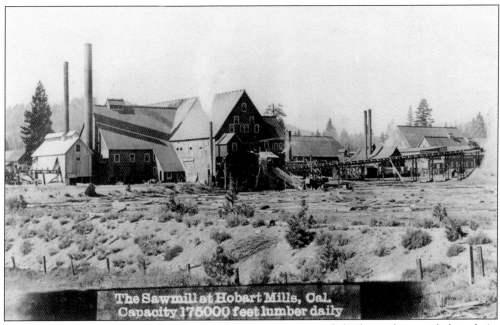

The Sawmill at Hobart Mills, Cal.
Capacity 175000 feet lumber daily

The sawmill capabilities of the Hobart Mills were enormous, while the timber supply lasted. At one time, the mill capacity was 175,000 board feet of lumber per day. Hobart was the terminus of the standard-gauge line from Truckee and the starting point for the narrow-gauge logging lines.

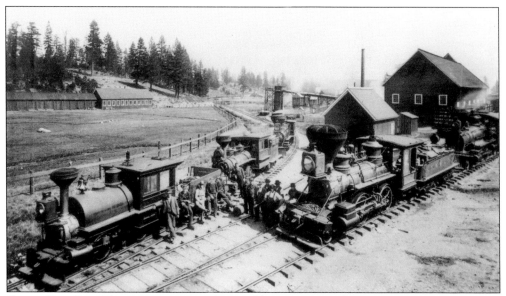

George Davidson Oliver was superintendent and later manager of SNW&L from 1900 until the operation closed down in 1937. One of his hobbies was photography. This c. 1902 portrait of Hobart Mills shows a confluence of the standard-gauge tracks on the right with two locomotives met by three narrow-gauge engines to the left. The respective train crews gathered in the center of the scene. (Photograph by George D. Oliver.)

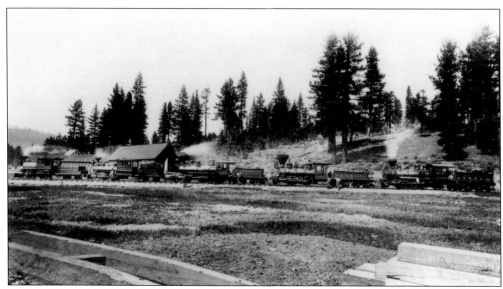

Dual-gauge trackage permitted this c. 1902 portrait of SNW&L's entire steam locomotive roster. From left to right are SNW&L narrow-gauge engines Nos. 1, 2, and 5, followed by standard-gauge engines Nos. 3 and 4. Nos. 1 and 2 came from Incline, No. 5 was ex–Eureka & Palisade No. 4, No. 3 was ex-V&T No. 21, and No. 4 was purchased new by SNW&L in 1901. (Photograph by George D. Oliver.)

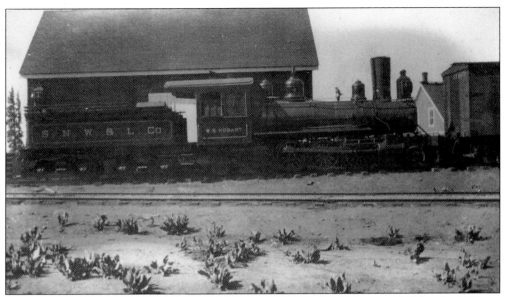

SNW&L standard-gauge No. 4 *W.S. Hobart* was out-shopped in February 1901 by the Baldwin Locomotive Works of Philadelphia. The Prairie-type wood-burner had 44-inch-diameter drivers, 13-by-22-inch cylinders, and a rated tractive effort of 13,120 pounds. The 2-6-2 had unusual dual sandboxes for increased traction and a backup headlight on the rear of the tender.

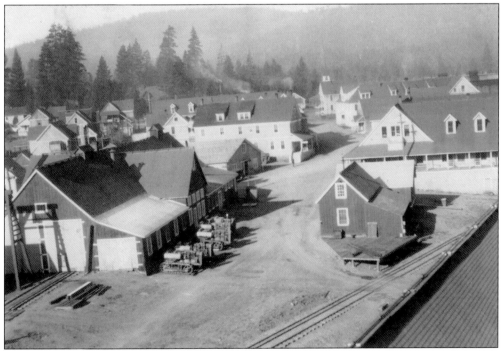

The photographer inscribed this Hobart Mills panorama as "From the Box Factory Roof." Steeply pitched roofs help shed the moisture-laden weight of winter snow on the "company town" of nearly 1,500 inhabitants. The visible tracks are all three-rail for dual-gauge operations. A two-track car repair shop is in the foreground at left, while the engine house is in the distant right. (Photograph by George D. Oliver.)

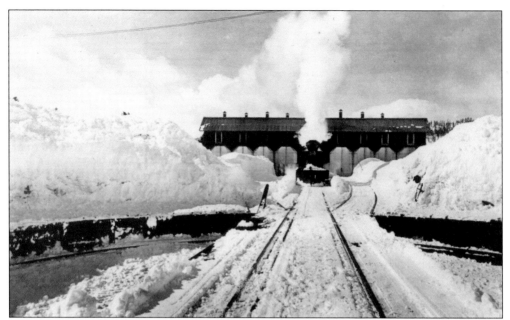

Located at 5,880 feet above sea level, Hobart Mills had its share of winter challenges. Standard-gauge SNW&L No. 3 with its pilot snowplow poses in front of the nine-track enginehouse after clearing out two leads at the turntable. The mounds of snow are the results of hand-shoveling out the pit so that the turntable will successfully operate. (Gilbert H. Kneiss collection.)

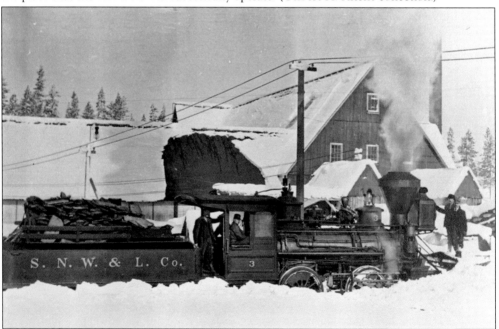

SNW&L No. 3 was a 2-4-0 switch engine and one of the first choices of engine crews to clear the tracks of accumulated snow. SNW&L's snow-fighting arsenal also included a flanger, a huge wedge plow, and homemade push plows anchored to the ends of narrow-gauge flatcars. The improvised flats were strenuously pushed by a couple of locomotives each spring in an effort to reopen the line. (Lake Tahoe Historical Society.)

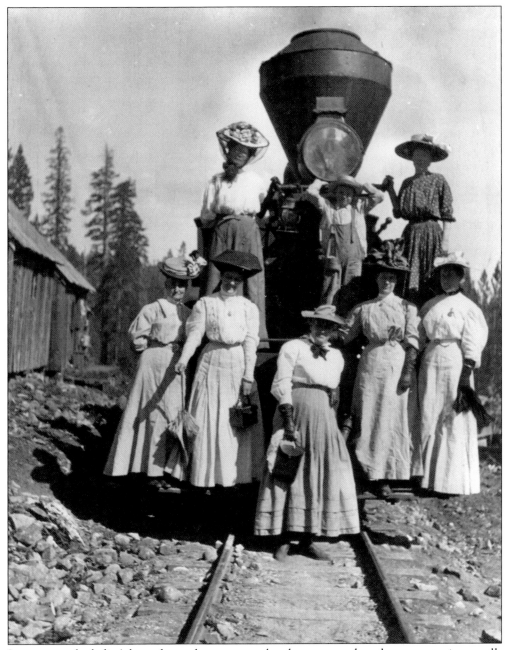

It appears to be ladies' day as hats, gloves, purses, lunches, a parasol, and a youngster in overalls adorn the front of Sierra Nevada Wood & Lumber Company narrow-gauge 4-4-0 No. 5. A seasonal six-day work week usually relegated picnics and other social outings to Sunday travel on the company's lines. (Nevada State Railroad Museum.)

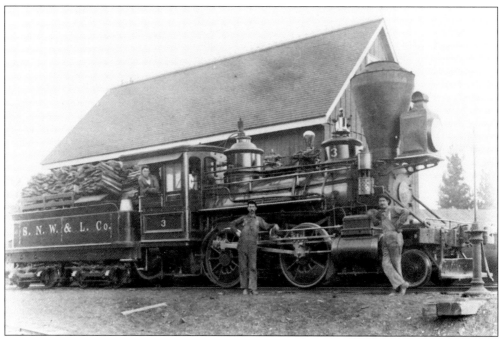

SNW&L No. 3 was built in 1875 by the Baldwin Locomotive Works as the V&T No. 21 *J.W. Bowker*. The 2-4-0 was named for the railroad's innovative master mechanic, John William Bowker. The engine was briefly renamed *Mexico* when the honor went to Bowker's head, and full of liquor, he had to be relieved of his duties. For almost two decades, No. 21 was the assigned switch engine at Virginia City.

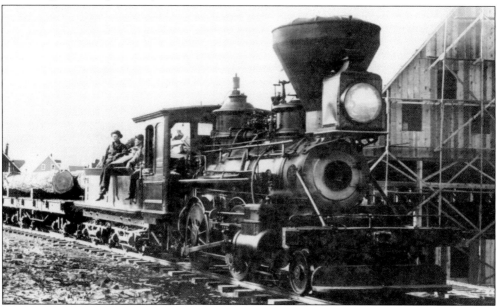

What looks like a plumber's nightmare atop the boiler of No. 3 is a single-cylinder Knowles steam pump for firefighting purposes. The powerful pump could draw water from the tender, a nearby stream, or other body of water. During the decline of the Comstock, SNW&L purchased the engine from the V&T in July 1896 for $4,000. (Michael A. Collins collection.)

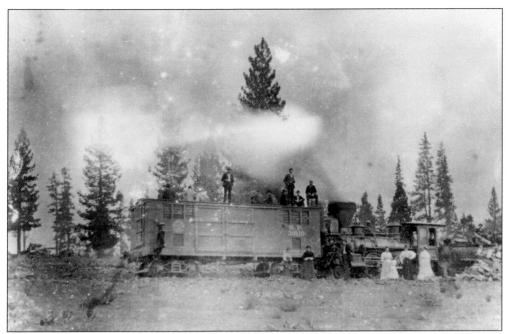

The tender of No. 3 is being wooded-up to push a Southern Pacific combination boxcar. For the first 30 years, SNW&L was strictly a freight-only railroad with no formal passenger service. The presence of the ladies in the foreground and the 11 men already on the boxcar give all the appearance of a pleasant Sunday outing.

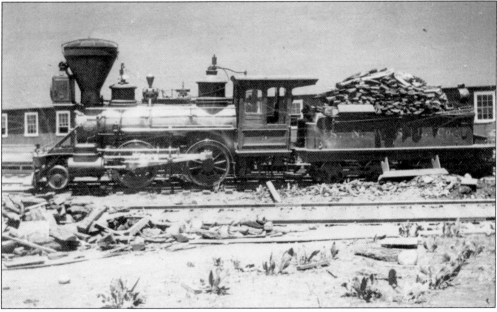

No. 3 was one of three SNW&L standard-gauge steam engines—all of them Baldwin locomotives. By 1907, the three-spot was replaced by newer locomotives, and it sat out its remaining years in the Hobart Mills enginehouse. When Hobart was winding up operations, the engine was presented in 1937 to the Pacific Coast Chapter of the Railway & Locomotive Historical Society for preservation. (Roy D. Graves collection.)

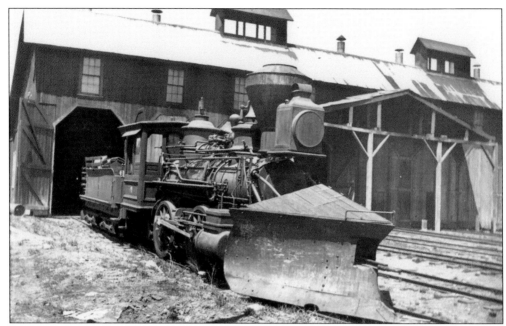

Minus its plow, the 1875 switcher was restored in 1938 for operation in Cecil B. DeMille's 1939 film classic *Union Pacific*, the 1939–1940 New York World's Fair, and the 1949 Chicago Railroad Fair. The venerable engine last operated in June 1953 in San Francisco. Re-lettered again as the V&T No. 21 *J.W. Bowker*, the famed wood-burner is part of the California State Railroad Museum in Old Sacramento. (Harold K. Vollrath collection.)

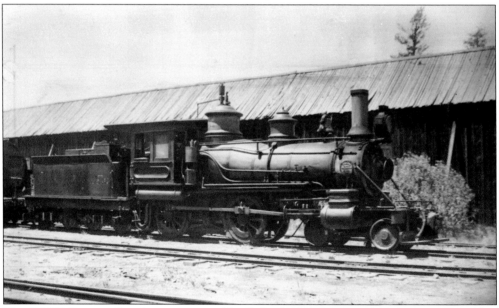

The SNW&L's secondhand narrow-gauge No. 5 also had a career on the silver screen. Sold to Warner Bros. in 1938, the 1875 locomotive appears in at least 10 feature-length motion pictures and television productions. The Baldwin engine has since been painstaking restored by Daniel Markoff of Las Vegas to its operable 1870s configuration as the wood-burning Eureka & Palisade No. 4 *Eureka*.

In 1917, SNW&L became the Hobart Estate Company and from 1932 to 1937 the standard gauge was operated as the common carrier Hobart Southern Railroad. Once the forest was denuded, the Hobart mills closed, and the last train was run in December 1937. Hobart Estate's rarely photographed Milwaukee center-cab gasoline switchers Nos. 1–3, the first delivered in 1909, were in Oakland, California, in September 1939 for scrapping.

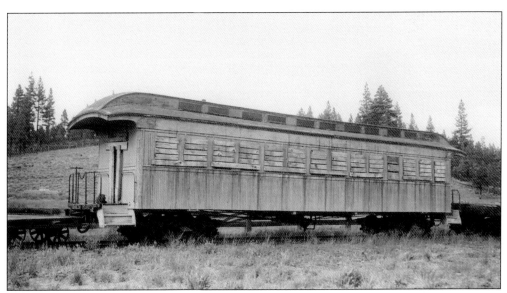

The 1884 Hobart Southern narrow-gauge coach was photographed at Hobart Mills in July 1939, just prior to its demise. The 40-foot-long ex–South Pacific Coast and former Nevada & California car was leased from around 1910 to 1926 for operation as Lake Tahoe Railway & Transportation Company No. 15. It then joined four other ex-LTRy&T passenger cars on Hobart Estate for their final dozen years. (Photograph by Guy L. Dunscomb.)

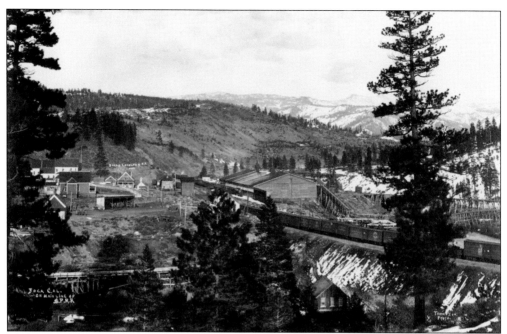

Boca is located just northeast of Truckee at the mouth of the Little Truckee River. In the early 1900s, Boca was a busy junction point on the Southern Pacific. In a view looking east along the Truckee River Canyon, the Union Ice Company warehouse and the SP main line are in the center while the short line B&L curves into Boca via a switchback on the left. (Grahame H. Hardy collection.)

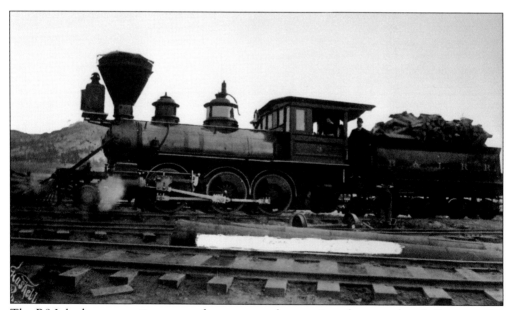

The B&L had a provocative roster of seven steam locomotives that were largely "opportunity acquisitions." The majority of the engines were 25 years old when they were purchased secondhand by the lumber carrier. B&L No. 3 was an 1876 2-6-0, the former Virginia & Truckee No. 23 *Santiago*, which the B&L purchased in October 1901 for $4,000. (James E. Boynton collection.)

Loyalton in Sierra County around 1908 was a bustling sawmill and box factory community. The Boca & Loyalton Railroad was incorporated in September 1900, and it connected its two namesakes in the summer of 1901 with 26 miles of standard-gauge track. The descent into Loyalton was 600 feet below Boca. At Loyalton were the B&L enginehouse and shops, three-story B&L depot, sawmills in the foreground, and the community of Loyalton in the distance. The three smokestacks in the center (above) belong to the Loyalton & Plumas Box & Lumber Company's works (below). Photographer R.T. Thompson captured smoke, steam, numerous railroad tracks, and many well-maintained buildings—all signs of a successful, enterprising business in the early 1900s. (Both, Grahame H. Hardy collection.)

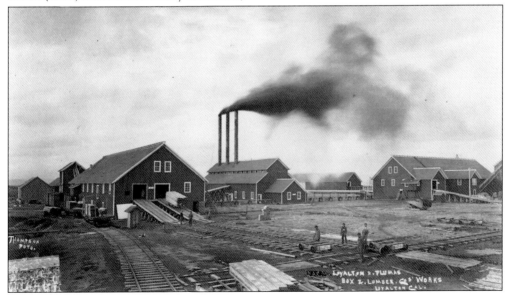

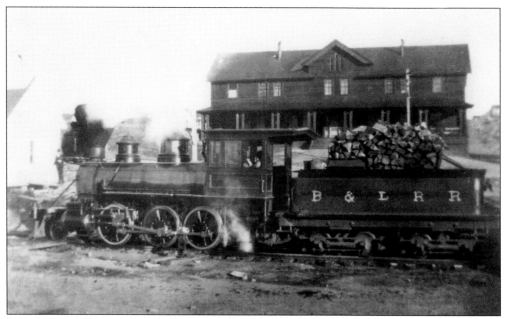

The B&L briefly rented its future No. 3 from the V&T for $15 per day in November 1900, before it purchased the engine. Like other lumber railroads, the B&L was plagued by fire, snow, floods, and accidents. After a bad fire in April 1907, No. 3 was extensively repaired in the V&T's Carson City shops, and it returned to the B&L burning fuel oil rather than wood. (Guy L. Dunscomb collection.)

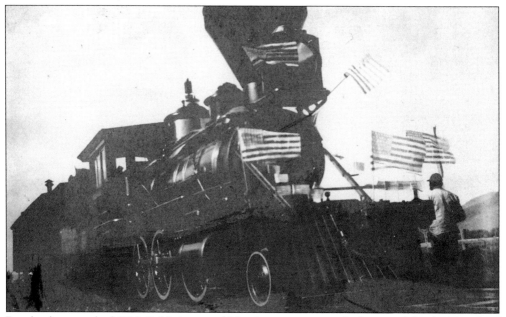

Rarely photographed B&L Baldwin mogul No. 4 was appropriately festooned for the Fourth of July around 1904 when preparing to leave Loyalton for Boca. As the former 1876 V&T No. 24 *Merrimac*, the freight-hauler was initially sold in 1900 as the Verdi Lumber No. 2 *Lonkey*. But returned to the V&T, the engine was resold two years later to the B&L. (Stanley F. Merritt Collection, California State Railroad Museum.)

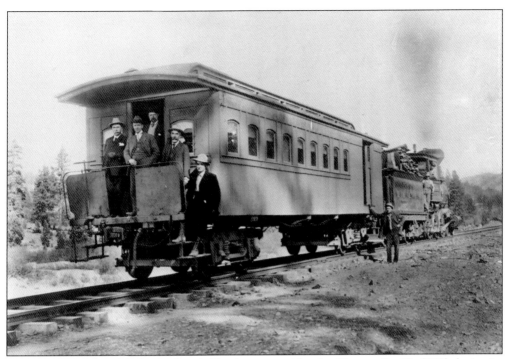

B&L 4-6-0 No. 7 and Caboose-Coach No. 1 were used by the Western Pacific (WP) during its track construction around Portola in 1908. WP vice president and chief engineer Virgil C. Bogue is on the platform at left while B&L superintendent W.S. Lewis is in the center of the doorway. The passenger car was built by the V&T in 1870 and sold to the B&L in April 1901 for $600. (Western Pacific Railroad.)

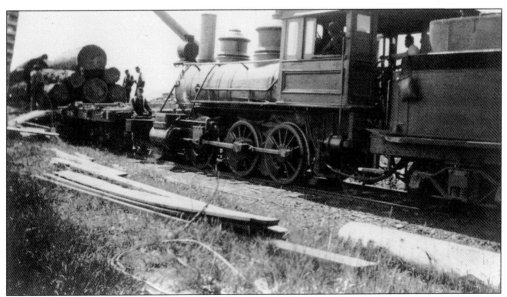

As an oil-burner, B&L No. 3 was still in use into 1914. In addition to its own seven locomotives, the B&L also variously rented V&T Locomotives Nos. 9, 12, 20, 22, and 23, Denver & Rio Grande Western Nos. 128 and 661, as well as a Southern Pacific locomotive. (Guy L. Dunscomb collection.)

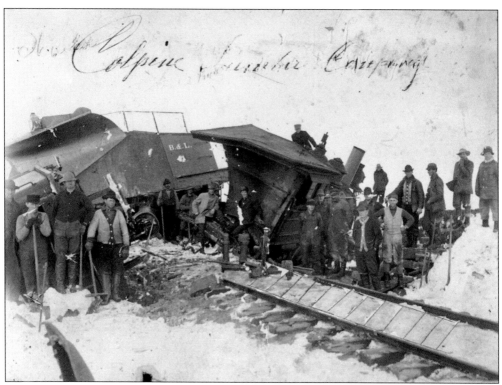

Workers pause from their work for this quick photograph of a derailed Boca & Loyalton locomotive and wedge snowplow while reportedly doing work for the nearby Calpine Lumber Company. The assembled railroad and lumber company employees are about to embark on the time-honored task of painstakingly jacking and cribbing the equipment back onto the rails.

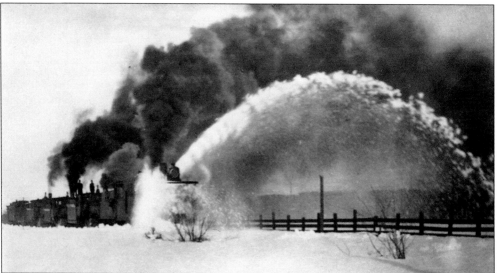

The 1911 image of several B&L locomotives pushing a borrowed rotary snowplow leaves little doubt about the effectiveness of the rotary in throwing light snow from the right-of-way. There were more than a dozen lumber spurs off the main line between Boca and Loyalton, but little logging occurred during winter months. (Photograph by R.T. Thompson.)

A 1907 letter from the B&L master mechanic to his counterpart at the V&T orders replacement parts for the ex-V&T Caboose-Coach No. 7 and one of the two 2-6-0 locomotives purchased secondhand from the V&T. In addition, the B&L purchased 22 flatcars from the V&T in 1900 and 1901. It also used the Carson shops for repairs and parts supply for many years.

In 1906, both the Boca & Loyalton and the Western Pacific were under the control of the D&RGW's George Jay Gould. The B&L went into receivership in June 1915 and received permission to abandon between Boca and Loyalton in November 1916. The remaining right-of-way and assets of the B&L were acquired in December 1916 by the Western Pacific. (Ron Lerch collection.)

French Canadian Oliver Lonkey was the spark plug behind the new Verdi Lumber Company (VL) and its standard-gauge railroad beginning at the turn of the 20th century. The first two locomotives and a dozen flatcars came from the Virginia & Truckee. Posing on VL 2-6-0 No. 1 *Roberts* are, from left to right, brakeman Orrin Barton, fireman "Tubby" Grignon, and engineer Ed Lonkey. (Gilbert H. Kneiss collection.)

Verdi Lumber Company

ON THE TRUCKEE RIVER

MANUFACTURERS OF

CALIFORNIA WHITE PINE

MINING TIMBERS A SPECIALTY

WHOLESALE AND RETAIL DEALERS IN GENERAL MERCHANDISE

VERDI, WASHOE CO., NEV., Apr. 2, 1907

Virginia & Truckee R. R.

Carson City, Nev.

Gentlemen:-

 Please ship us as soon as possible, two sets driver brake shoes for front and rear driver, we already have two new sets for the middle or blind driver. Also send us two complete sets brake shoes for tank. All of above for our #1 locomotive.

Yours very truly,
VERDI LUMBER COMPANY,

Per.

In April 1907, Verdi Lumber's C. Lonkey ordered two sets of brake shoes for the flanged drivers and tender of 2-6-0 No. 1 from the V&T shops in Carson City. Verdi Lumber acquired the former No. 19 *Truckee* from the V&T in May 1901 at a cost of $4,000, plus $545.63 for the addition of air brakes. In late 1907, the V&T converted the engine to burn fuel oil.

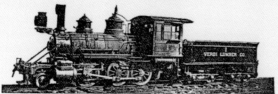
Verdi Lumber No. 1 survived repeated floods and fires on the Verdi lumber line. The V&T supplied parts for the engine through 1918. Proud of the 2-6-0's 45-year record, the Baldwin Locomotive Works placed an illustrated advertisement in the May 1920 issue of *Timberland*. The venerable mogul was finally scrapped in Oakland, California, in 1927.

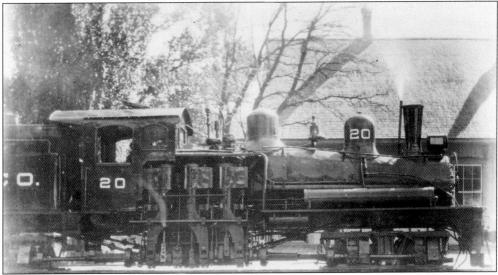

In addition to the two Baldwin rod engines, Verdi Lumber had 5 two- and three-truck Lima Shays for the timberline's sharp curves, switchbacks, and steep grades. Shay No. 20 was repaired in the V&T's shops and was photographed under steam in October 1924 outside the Carson City Passenger Depot. The V&T shops variously serviced all seven of the VL's steam locomotives. (Roy D. Graves collection.)

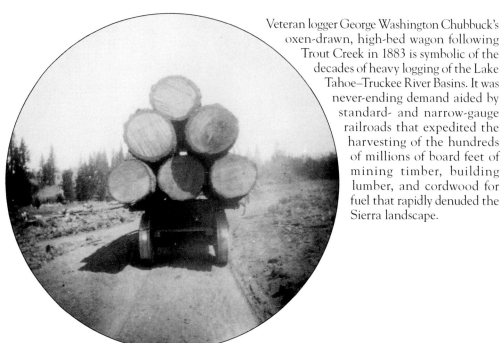

Veteran logger George Washington Chubbuck's oxen-drawn, high-bed wagon following Trout Creek in 1883 is symbolic of the decades of heavy logging of the Lake Tahoe–Truckee River Basins. It was never-ending demand aided by standard- and narrow-gauge railroads that expedited the harvesting of the hundreds of millions of board feet of mining timber, building lumber, and cordwood for fuel that rapidly denuded the Sierra landscape.

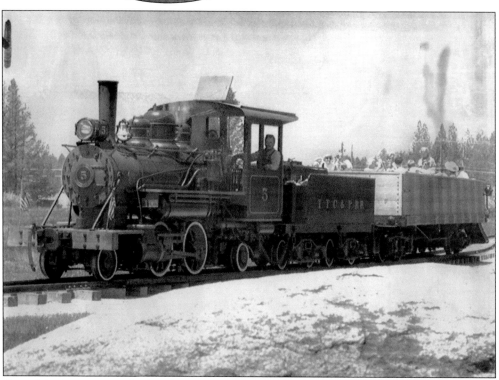

One of the last vestiges of railroads repurposed for tourism at the majestic lake was the short-lived Tahoe, Trout Creek & Pacific Railroad (TTC&P). Commencing in July 1970 at South Lake Tahoe, TTC&P 2-4-2 No. 5 was the last regular passenger train at the lake, ending nearly a century of steam railroad operations at Lake Tahoe.

Nine

Saving the Locomotive Glenbrook

One of the last artifacts of Lake Tahoe's diverse narrow-gauge system was still largely intact outside the Lake Tahoe Railway & Transportation Car shop in Tahoe City in the early 1930s. LTRy&T 2-6-0 No. 1, the former Carson & Tahoe Lumber & Fluming Company *Glenbrook*, had seen decades of operation on both Tahoe shores at first Glenbrook and later Tahoe City. Eventually, the mogul was languishing on the Nevada County Narrow Gauge Railroad at Grass Valley, California, where it became a source of spare parts.

Enter Hope Danforth Bliss, born in 1870 in Gold Hill and the only daughter of Duane and Elizabeth Bliss. Out of history and sentimentality, she purchased the old engine from scrappers and donated the venerable wood-burner in September 1943 for the new Nevada State Museum at Carson City. Moved via flatcar from Colfax via Southern Pacific and the Virginia & Truckee, the little 2-6-0 was cosmetically spruced up and placed on the grounds of the new museum for the enjoyment of generations of admirers.

In July 1981, the engine was briefly trucked to Glenbrook, Nevada, for display, and it was then moved into the new state railroad museum in south Carson City for eventual restoration.

The 1875 Baldwin as-built classification numbers for the C&TL&F's first two engines were 8-20 D No. 12 for the *Tahoe* and 8-20 D No. 13 for the *Glenbrook*. Years of research finally confirmed that the C&TL&F had numbered the engines just the opposite—the *Tahoe* became C&TL&F No. 2 while the *Glenbrook* was actually numbered 1 and later 4.

The restoration and full return to an operable c. 1875 appearance was a multi-decade task in the capable hands of the restoration shop artisans at the Nevada State Railroad Museum (NSRM). Unveiled in May 2015, the operating *Glenbrook* is a magnificent 140-year-old artifact of the halcyon days of Lake Tahoe's railroads.

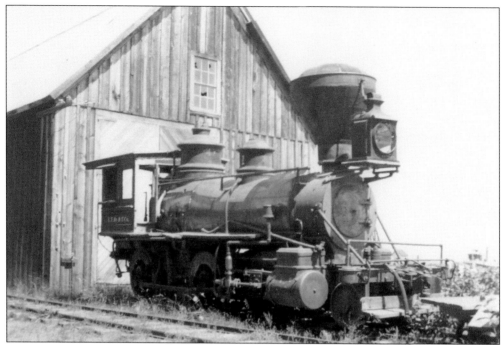

LTRy&T three-foot-gauge No. 1 became surplus in 1926 when Southern Pacific converted the 15-mile line to standard gauge. Stored outdoors at Tahoe City, No. 1 was occasionally fired up and used with flatcars to pull boats out of Lake Tahoe for winter periods. (Bert H. Ward collection, courtesy Daniel D. Webster.)

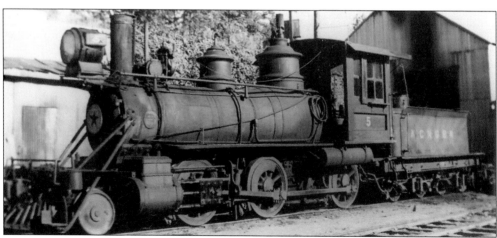

The *Tahoe*, the identical twin to the *Glenbrook*, was sold in June 1899 to the Nevada County Narrow Gauge Railroad at Grass Valley to become NCNG No. 5. It was resold to Universal Pictures in 1940 and now resides in the Nevada County Narrow Gauge Railroad Museum in Nevada City, California. (Daniel D. Webster collection.)

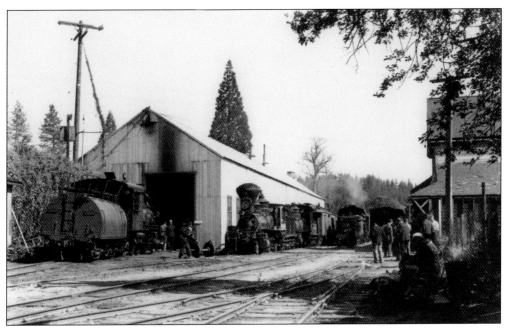

LTRy&T No. 1 never operated on the NCNG and it retained its LTRy&T Company roster number and lettering during the six years it was at Grass Valley. During a May 1937 excursion trip by the Pacific Coast Chapter of the Railway & Locomotive Historical Society (above), No. 1 was spotted opposite the Grass Valley depot, alongside the machine shop. Like a ghost from the past (below), No. 1 was a cadaver in the NCNG's deadline—a source of spare parts to keep the NCNG's other early Baldwin's in repair. Fortunately, many old parts were found on the NCNG when the fabled engine was purchased by Hope Bliss. (Above, photograph by Roy D. Graves; below, Josiah F. Hobart collection.)

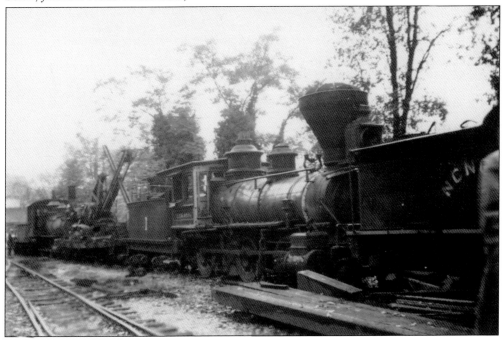

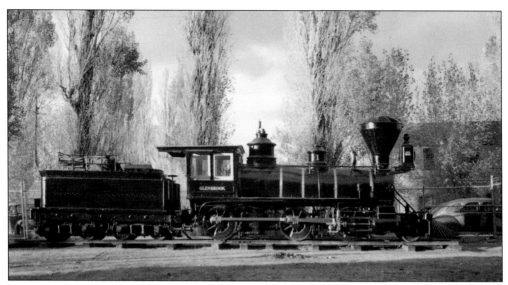

Mechanical personnel from the Virginia & Truckee Railway shops helped to cosmetically rejuvenate old No. 1 for static display on the grounds of the Nevada State Museum's US Mint Building in Carson City. In 1948, the engine was moved east on the site so as to have greater visibility along North Carson Street and US Highway 395. (Photograph by David J. Welch.)

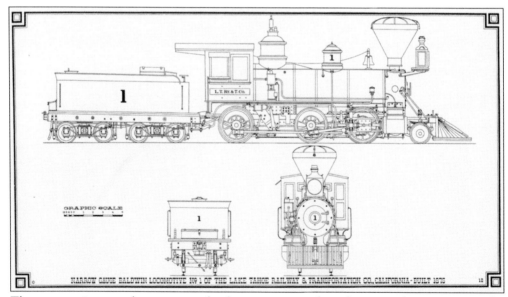

The centenarian soon became one of only six surviving three-foot-gauge locomotives in the United States built prior to 1880. Fortunately, a great body of documentation, specifications, drawings, records, pictorial materials, and historical information still survived to support an accurate return to operation of the 1875 locomotive. (Ink on linen drawing by Frederic J. Shaw, courtesy California State Railroad Museum.)

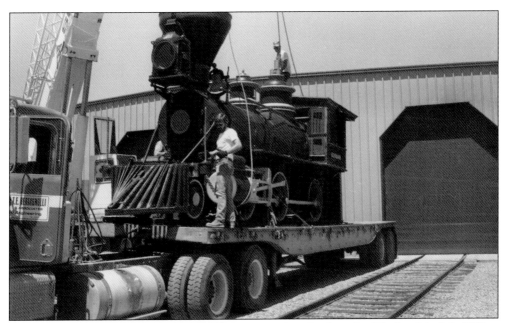

Nevada State Museum director Scott Miller assists with unloading the *Glenbrook* in July 1981 at the new V&T Railroad Museum in Carson City. After 38 years on exhibit in downtown Carson City and brief display at Glenbrook, the engine was relocated for a multiyear return to operation by the knowledgeable staff of the Nevada State Railroad Museum (NSRM). (Photograph by Daun Bohall.)

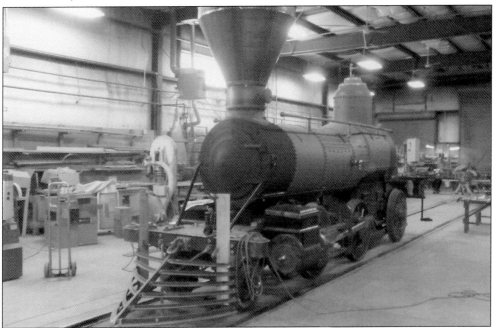

No. 1 was stripped to its frame and drivers, carefully evaluated, and then painstakingly reassembled for reoperation. Tired or missing components were meticulously replaced in-kind, without compromise. The Nevada State Railroad Museum's restoration set new standards of accuracy and excellence that are now being emulated at other railroad museums throughout the country.

A look inside the full-dimension ash cab of the *Glenbrook* makes it obvious that steam locomotive appliances and operation was considerably simpler in 1875. The engineer sat on the right while the fireman was on the left. The firebox door, throttle, and steam gauge are squarely in the center of the backhead in this progress view taken inside the NSRM Restoration Shop.

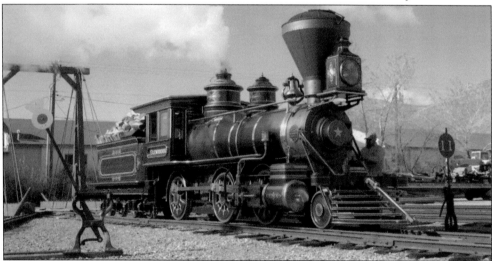

The completed locomotive is spectacular—a historically accurate restoration backed by industrial archaeology and scholarly research. The engine is resplendent in its dark blue Russia Iron–style jacket, highly polished machinery, brass, and copper components, painted maroon surfaces, and a profusion of red, white, and gold striping. (Photograph by Wendell W. Huffman, Nevada State Railroad Museum.)

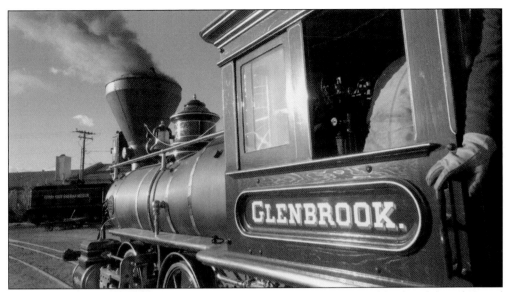

After being silenced for some 80 years, the restored *Glenbrook* steamed back to life and moved once again under her own power in 2015. Museum staff are working hard to expand the three-rail track on site so that the seasonal public demonstration railroad experience can further expand. (Photograph by Wendell W. Huffman, Nevada State Railroad Museum.)

The Nevada State Railroad Museum has distinguished itself for its fine restoration program, more than 100 active volunteers, and its high-quality interpretive exhibit program. The engaging story of Lake Tahoe's railroads is shared daily with the Museum's 30,000 annual visitors. The *Glenbrook* could not be in better hands.

Discover Thousands of Local History Books Featuring Millions of Vintage Images

Arcadia Publishing, the leading local history publisher in the United States, is committed to making history accessible and meaningful through publishing books that celebrate and preserve the heritage of America's people and places.

Find more books like this at
www.arcadiapublishing.com

Search for your hometown history, your old stomping grounds, and even your favorite sports team.

Consistent with our mission to preserve history on a local level, this book was printed in South Carolina on American-made paper and manufactured entirely in the United States. Products carrying the accredited Forest Stewardship Council (FSC) label are printed on 100 percent FSC-certified paper.

MADE IN THE
USA